HOW TO LOOK AT JAPANESE ART

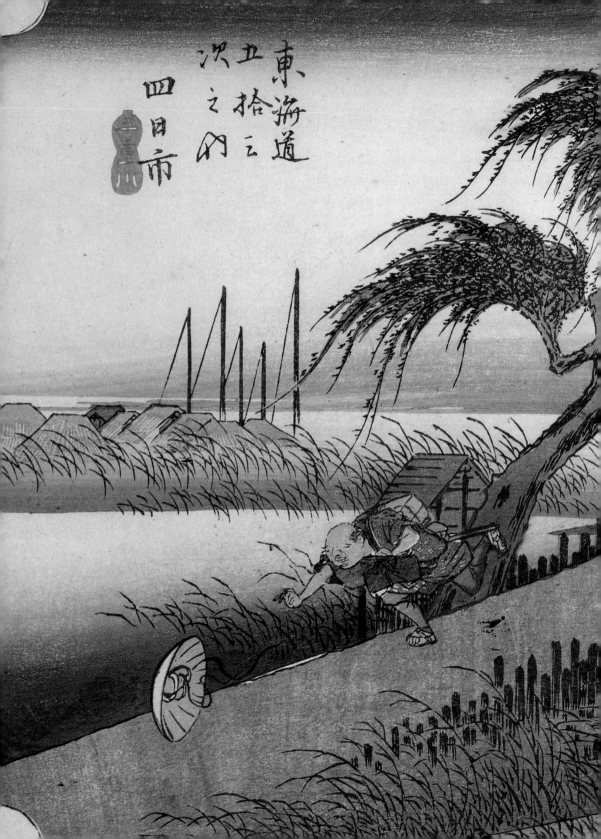

HOW TO LOOK AT JAPANESE ART

Stephen Addiss
with a chapter on gardens by
Audrey Yoshiko Seo

Harry N. Abrams, Inc., Publishers

To Joseph Seubert

PROJECT MANAGER: *Julia Moore*
EDITOR: *James Leggio*
DESIGNER: *Darilyn Lowe Carnes*
PHOTO RESEARCH: *Helen Lee*

Library of Congress Cataloging-in-Publication Data
Addiss, Stephen, 1935–
 How to look at Japanese art / Stephen Addiss with a chapter on
 gardens by Audrey Yoshiko Seo.
 p. cm.
 "Ceramics, sculpture and traditional Buddhist art, secular and
 Zen painting, calligraphy, woodblock prints, gardens."
 Includes bibliographical references.
 ISBN 0–8109–2640–7 (pbk.)
 1. Art, Japanese. I. Seo, Audrey Yoshiko. II. Title
N7350.A375 1996
709' .52—dc20
 95–21879

FRONT COVER: Suzuki Harunobu (1725–1770), *Girl Viewing Plum Blossoms at Night* (see figure 50)
BACK COVER, FROM LEFT TO RIGHT, ABOVE: *Ko-kutani Platter*, 17th century (see figure 7); Otagaki Rengetsu (1791–1875), *Sencha Teapot* (see figure 46); *Fudo Myoo*, c. 839 (see figure 18). BELOW: Ryo-gin-tei (Dragon Song Garden), Kyoto, 1964 (see figure 63). BACKGROUND: Page of calligraphy from the *Ishiyama-gire*, early 12th century (see figure 38)
ON THE TITLE PAGE: Ando Hiroshige (1797–1858), *Yokkaichi* (see figure 55)

Text copyright © 1996 Stephen Addiss
Gardens text copyright © 1996 Audrey Yoshiko Seo
Illustrations copyright © 1996 Harry N. Abrams, Inc.

Published in 1996 by Harry N. Abrams, Incorporated, New York

Printed and bound in Japan

CONTENTS

ACKNOWLEDGMENTS

*S*incere thanks are due to the following friends and scholars: Sylvan Barnet and William Burto, for their thorough and thoughtful reading of the manuscript; Darilyn Lowe Carnes, for her elegant design of the book; Saralyn Reece Hardy, for her generous advice; Janet Ikeda, for useful conversations on *waka*; James Leggio, for his insightful editing of the text; Richard and Sachiko Lethen, for their ideas and encouragement; Richard Mellot, for his fine suggestions on the ceramics chapter; Julia Moore, for her warm support of the entire project; Samuel Crowell Morse and Anne Nishimura Morse, for sharing their knowledge of sculpture; and Abijah Reed, for his technical expertise and for suggesting fascinating comparisons.

S. A.
A. Y. S.

INTRODUCTION

Recently, I was asked to write two chapters on the arts of Japan for ART HISTORY, a major survey of world art by Marilyn Stokstad, the distinguished professor of medieval art. I was delighted but perplexed by this assignment. How could I convey the beauty and variety of Japanese art to general readers in just two chapters? Of course, I could describe and illustrate a number of masterworks, but was this enough? Ultimately, I wanted to do more for an art that had so surprisingly changed and enriched my existence.

Until my thirties, I had believed that my life would be devoted to music. After graduating from college, I found myself composing concert music and traveling in Asia, Africa, and Europe to present concerts of traditional and folk music of many countries. Yet when I first visited Japan, the initial impact of seeing Japanese Zen painting was startling; I had no idea that any form of visual art could have so much meaning for me. While I continued the concert tours, I began to study Japanese art.

For the first few years, I read whatever I could find in English, took lessons in brush painting and calligraphy, and visited museums and collectors to see Japanese works face-to-face. Finally, I enrolled in graduate school to tackle the difficulties of the Japanese language and to begin a more formal study of the many arts of Japan. I continued performing and composing during these years, but after receiving my Ph.D. jointly in art history and musicology from the University of Michigan, I ended my performing career in order to write, paint, and compose, and to teach art history as a profession.

What is it about the artistic culture of Japan that can so transform a life? Words alone cannot answer this question; only looking, seeing, and understanding can. But how shall we look at Japanese art in order truly to *see* it?

A trip to Japan obviously can be helpful, but even when this is possible, it can lead to some confusion. First-time visitors to Japan usually expect one of two things: either a world of skyscrapers, crowds, and immense corporations, or a land of ancient temples, refined culture, and Zen meditation.

Both are there.

You may wait on line with dozens of other people to cross the street at a noisy city intersection, or sit quietly facing a rock-and-sand garden in a Buddhist monastery. A few minutes

after being squeezed into an impossibly crowded train on the busiest subway system in the world, you may find yourself kneeling peacefully on *tatami* matting to receive a ritual cup of green tea in the most hushed and refined of settings.

So how are we to understand Japan, a land of simultaneous opposites, where Eastern and Western traditions are both flourishing? This is not an easy question to answer, but surely one of the best ways is through its art, which has embodied the deepest values of Japanese civilization for thousands of years. Japanese art, however, like Japanese life, is multiple rather than unitary. In fact, it too is full of opposites: the most ornate and the most minimal; the oldest and the newest; the most colorful and the most subtle. How are we to understand it all?

There are two main routes to the understanding of art. The first is through visual analysis, where the beauties of form and style can be studied and appreciated. Here, the clean lines, strong design, and dramatic appeal of Japanese art come to the fore. The second is through cultural history, the larger world that surrounds artists and their patrons. In this approach, the study of Japanese religion, literature, theater, and music all can help us to absorb the content of the art. We will try to combine the two methods, with a special focus on the visual features that are unique to Japanese art.

Even when the form or basic style has been borrowed from another country, there is always something "Japanese" about Japanese images. Defining this quality, however, is very difficult. Japanese art can range from the extraordinarily simple to the extremely complex, from the profoundly spiritual to the brightly decorative, from the fully traditional to the curiously novel, and from the highly sophisticated to the most basic and rough. What, then, are the typical Japanese features?

One characteristic is a deep understanding and respect for nature, including human nature. This appears in subject matter—such as birds and flowers, landscapes, or human figures in daily activity—and it is also apparent in artistic approach. For example, there is great respect for the natural materials from which a work of art is created. In Japanese ceramics, the sense of the clay itself often determines the beauty and character of the completed bowl, vase, or plate. In sculpture, the quality of the wood, clay, or bronze is allowed to show through the carving or molding of the particular form. In painting, it remains clear that we are looking not only at the subject, but also at ink or colors on paper or silk. And in woodblock prints, the texture of the carved wood is part of the aesthetic of the completed image.

Above all, there is a sense of "naturalness" in Japanese art that often describes nature in particular seasons, times of day, and weather conditions. Each of these calls forth to the Japanese sensibility a particular emotion, such as the melancholy of autumn rain at dusk.

The feeling of naturalness extends to the artist's technique, which often seems to have emerged spontaneously, based on the feeling of the moment. As we shall see, however, this evocation of naturalness is often complex, since Japanese artists may have worked in very sophisticated ways to achieve the feeling of natural expression. Nevertheless, in most Japanese art a sense of the vital rhythm and expressive force of nature is more important than elaborations of technique.

Another characteristic of Japanese art is its ability to borrow and transform features from the arts of other countries. Successive waves of influence from China and Korea brought to Japan Buddhism, a written language, and new forms of government, as well as different styles of art. These might have overwhelmed a less confident and creative people. In Japan, however, they were quickly transformed into traditions that have endured for centuries. In the past 140 years, Western influence has entered almost every aspect of Japanese life, including the arts, but again, the foreign influence is being modified to suit Japanese temperament and vision.

A third recurring characteristic in Japanese art is the importance of space, often empty space allied with asymmetrical compositions. It is no accident that traditional Japanese poetry is written in five lines (*waka*) or three lines (*haiku*), rather than the paired lines of most Chinese and Western poetry. Symmetry often implies rationality and timeless balance, while the asymmetry and open space of Japanese art can suggest emotion and a sense of movement and change.

A fourth characteristic of Japanese art, particularly in contrast to Chinese, is the ability to go to extremes. The same artist will paint vivid colors on a golden screen one day and dash a few strokes of ink on a corner of plain paper the next. There is no feeling of oddness in this contrast, but rather the enjoyment of each artistic feature being carried to its ultimate conclusion. Artistic opposites do not contend with each other in Japan, but are accepted as valuable to human experience in their different ways.

As a last characteristic, humor and playfulness pervade much Japanese art. Demons and devils are shown in Buddhist images not only to warn against the dangers of evil conduct, but also to give a sense of their legitimate place in the fabric of natural and supernatural life. Human foibles are lampooned, but not with bitter or sarcastic intent. Instead, we are all regarded as foolish and wise, good and bad, in equal measure, and Japanese art teaches us to laugh at ourselves so as not to feel superior to all the other sentient beings with whom we share the earth.

In this book, as we journey through many centuries and six different artistic mediums, we will see these characteristics appear, seemingly vanish, and then reappear in new guises in

different epochs. Above all, Japanese art is characterized by joy. Color, forms, and line all contribute to a sense of buoyant movement, of dance—of wonder and delight.

The arts of Japan are among the richest and most expressive traditions in the world, and like all forms of art, they repay close attention and study. In some ways, however, they defy analysis because of their direct and evocative appeal. Words and explanations are not enough; art comes alive through experience. The purpose of this book is to encourage interested viewers to encounter Japanese art firsthand. These pages are intended to supplement and enrich this experience by investigating the mediums of ceramics, sculpture, painting, calligraphy, prints, and gardens.

It has been said that there are no minor arts in Japan; we might equally well have chosen to study lacquer, textiles, flower arranging, basketry, sword guards, architecture, miniature *netsuke* carvings, or the preparation and serving of food. However, since most viewers in America and Europe can visit museums to see ceramics, sculpture, paintings, calligraphy, and prints, and because many people have access to some form of Japanese garden design, this book will focus on these six arts. Through their visual forms, the profound sense of beauty created in Japan over the ages can become part of our own artistic heritage.

Although books and illustrations can certainly help us to understand art, seeing the objects firsthand is vital. Many museums in America have notable collections of Japanese art. Going with a friend can be helpful, since four eyes see more than two. Discussing the works that you see together is a good way to explore your thoughts and impressions—and it is always fascinating to know how differently people can view the same works of art. But going alone is also important, since it gives you the time to absorb each work at your own pace, and to consider how your own background and personality interact with your impressions of the art.

There are other ways to deepen your reception of art. One method is to stand in front of a work, take in as many aspects as possible, then turn around and try to re-create the work in your mind's eye. Turn back; have you missed something? Try again; each time you will see and absorb new aspects of the art.

Another useful method is to make sketches of what you see. This does not require artistic skill, since a very rough sketch is enough to help you determine whether the work is busy or spacious, serene or dynamic, curving or angular, and naturalistic or idealistic.

Sketches can also be made in words. How would you describe the work to someone who has not seen it? What if you were to write a short essay about the work? Putting ideas to paper can be very helpful; the book *A Short Guide to Writing About Art* by Sylvan Barnet has many good ideas in this regard.

When you face a work of art, you can ask questions: Why was the work made? What was its use? Was it intended for religious purposes? For decoration? For practical needs? To express delight, sorrow, or mystery? To communicate an individual vision, or a group's beliefs? Or simply to exist? At the end of each chapter in this book, there will be a list of key questions to explore.

Study of the culture will certainly help you answer these questions, but your personal responses are also valuable, because they bring life to objects from the past. Art is a process, always changing, and always enlivened by fresh vision and honest responses.

Once we have discovered which works of art can intrigue, move, and ultimately illuminate us, we often make them our favorites. But while it is good to revisit works that you already like, it is also valuable to spend time with art that you have not known before. Some works have an instant appeal, but you can gradually expand your range to examine works that may have different, perhaps more subtle, aesthetic qualities. You may still conclude that you do not care for them, but you will have learned more about your own taste and sensibility. And if you do respond to these previously unknown works, you will have enriched your life.

The most important point is to look, not only with your eyes but also with your mind. Art tells us about all the different things it means to be human, in every country, in every period. In the past century or so, it has been our privilege in the Western world to begin the study of Japanese art. If we look more fully, our pleasure and our understanding can be greatly enhanced. If we truly learn to *see,* Japanese art can become a joyful and transforming experience.

OUTLINE OF JAPANESE HISTORICAL PERIODS

Jomon, c. 10,500–c. 300 B.C.E. An age of hunting and gathering leads to the beginnings of agriculture. This period is named for its "cord-marked" pottery, the earliest ceramics now known in the world.

Yayoi, c. 300 B.C.E.–C.E. c. 300. Large-scale cultivation of rice is developed. Pottery becomes simpler and more elegant. The technology of bronze is introduced.

Kofun (Tumulus; Old Tomb), c. 300–552. Named for its gigantic tombs, on which were placed ceramic haniwa sculptures.

Asuka, 552–646. The first historical period. Buddhism, a writing system, and forms of governmental organization are all introduced to Japan from Korea and China.

Nara, 646–794. The capital is established at Nara. Traditional Buddhist arts and architecture reach a high level of development.

Heian, 794–1185. The capital is moved to Kyoto (originally called Heian), and court culture is brought to an extraordinary level. The narrative handscroll form of painting is developed. Esoteric and Pure Land sects of Buddhism gain popularity.

Kamakura, 1185–1392. Warrior leaders establish a new military government. Zen Buddhism is introduced. The capital is moved to Kamakura.

Muromachi (Ashikaga), 1392–1568. The capital is moved back to Kyoto. Zen culture dominates many forms of art, including ink landscape painting. Ashikaga Shoguns (warlords) rule until the country is beset by civil wars between feudal clans.

Momoyama, 1568–1600. Warlords finally reunite Japan. The first Westerners arrive. Splendid castles are built and decorated with boldly painted golden screens.

Edo (Tokugawa), 1600–1868. Japan is at peace under the rule of Tokugawa Shoguns, who move the capital to Edo (Tokyo). The outside world is excluded. A mercantile society develops within Japan. The arts flourish in many forms, including woodblock prints.

Modern (Meiji, Taisho, Showa, and Heisei), 1868–present. Japan opens to the Western world and becomes an industrial nation. Western-style and traditional arts coexist.

Note: In this book, Japanese names appear in traditional style, with the family name first and the given name second. For Zen monks, however, both names are Buddhist names. In the captions, dates of the art works are given whenever known.

PRONUNCIATION GUIDE

Japanese is not a difficult language to pronounce; the vowels, for example, are quite like those in Italian:

a = *ah* (as in "ma" and "ha")
e = the sound between *eh* and *ay*, without the final "ee" (that is, between "men" and "main")
i = *ee* (as in "he" and "she")
o = *oh* (as in "so" and "row")
u = *oo* (as in "sue" and "blue")
y = *ee* (as in "he" and "she")

Diphthongs combine two vowel sounds, as with *ai* ("ah-ee"). Therefore, the word *hai* ("yes") is pronounced "high."

Consonants are as they look, but the g is always hard, as in "again," not as in "gentle."

Unlike English, there is no accentuation of the penultimate syllable. Therefore, the name *Hiroshige* is pronounced "He-row-she-geh," not "He-row-SHE-geh."

Examples for Practice

Yayoi (a prehistoric era): "Yah-yo-ee"
Heian (an early historical period): "Hey-ahn"
Horyu-ji (a famous early temple):
 "Ho-ree-oo-gee"
Taiga (the literati artist): "Tah-ee-gah"
Ikkyu (the Zen Master): "Eek-kee-you"
Hokusai (the woodblock-print artist):
 "Ho-koo-sigh"
Shisendo (a famous garden retreat):
 "She-sen-dough"

1. CERAMICS

*T*he most basic question we can ask of a work of art is: Why does it look like that? We can begin with this reply: Because the artist *wanted* it to look like that. It was not by mistake, or from not knowing better, or from lack of skill. If a Japanese ceramic looks extremely simple, or strangely shaped, or very informal, that was part of the purpose of the artist.

But we may then ask: *Why* did the artist want it to look like that? This question can take us a long way into the beauties of Japanese art. Let's start with the materials used by the artist. Ceramics are made from fired clay, and this fact is celebrated by the Japanese artist. Unlike many prized ceramics from other countries, Japanese pots, vases, and tea bowls usually derive much of their beauty from the nature of the raw clay out of which they are constructed, and from the kind of firing they are given. This is as true today as it was when the first Japanese ceramics were created, twelve thousand years ago.

Prehistoric Ceramics

New methods of scientific "fission-track" dating have established that Japanese ceramics may be the oldest in the world. So far, nothing as early as the pottery of the Jomon era has yet been found in other parts of the globe, much to the surprise of the many anthropologists who had assumed that Japan was a follower, rather than a leader, among early civilizations.

The prehistoric Jomon period extended roughly from 10,500 to 300 B.C.E. and takes its name from the *jomon* ("cord-marked") pottery that has been recovered from many sites in southern and central Japan. During this long era, food was mostly hunted, fished, and gathered, and agriculture only gradually came to play a significant role. Most other hunting-gathering peoples have been nomadic, with no use for heavy or cumbersome possessions that had to be carried from site to site. It is believed that, in general, pottery does not develop until cultures reach an agricultural stage, when the need for storage and the cooking of grains becomes much more important. However, with their abundant food resources, many Jomon settlements could be maintained year-round, and this must have led to the production of large storage and cooking jars.

Among the foods of the early Jomon people were edible plants growing in the wild, fish and seafood, meats of many kinds, and nuts that were gathered in the fall and dried for winter provisions. The earliest Jomon ceramics, created about 10,000 B.C.E., are generally large, cone-shaped cooking pots. They have pointed bodies, providing both stability when placed into the earth or sand and a larger surface area for the cooking fire to heat up. The outer surfaces of the pots are usually rolled or stamped with rope or

cord patterns, giving the vessels more strength because the patterned clay becomes more compressed, as well as adding textural interest.

The pots were made with the coil method, in which successive coils of clay are placed on each other, sometimes completely smoothed down and sometimes not, creating a thick, slightly irregular, and strongly "built up" appearance. Firing took place in open pits or ditches, and since the heat reached only between 600 and 750 degrees, the pots were somewhat porous to liquids; these low-fired ceramics are called earthenware.

By about 5000 B.C.E., Jomon people were planting and harvesting beans and gourds to add to their diet; this was the beginning of Japanese agriculture. Ceramics became even more important, developing into several hundred different types. The most remarkable of these were produced in what is called the Middle Jomon period, between 2500 and 1500 B.C.E. At this time, some extraordinary decorations were added to pottery, although the basic shapes of these vessels for cooking and storage were straight-sided. Some of the decorations were added to the sides of the ceramics, but most notable are the extravagant and imaginative rim designs. Many patterns are purely geometric, such as ovals, circles, and spirals, but other shapes resemble masklike human or animal faces. These add an element of animism that gives the ceramics a sense of mysterious energy.

Two deep pots from the Middle Jomon era show some of the features that characterize this unique form of ceramics (figure 1). The shorter vessel, on the right, has a single design rising above the rim, an organic oval shape that might be the most basic form of a mask. Is this a face, with the two holes suggesting eyes? If so, the very small curl at the front of the rim could be hands joining together, although, strangely, they

are not directly across from the mask but are placed a little to one side. Beneath the rim is a simple, but again irregular, linear design, while the main body of the pot has diagonally rippling cord markings. The deliberate use of asymmetry evident in this pot is rare in early ceramics from other countries, and represents a special Japanese artistic characteristic that can be seen in many forms of art from many different eras.

The larger pot, on the left, has three raised rim areas, less animistic but very boldly shaped. Although the forms seem angular, they arise from swirling forms that have their echoes below in the powerful, twisting shapes that seem to dance across the main body of the pot. It is this energy that gives rise to the rim designs, reaching out beyond the usefulness of the pot to express something more.

What led to such artistic effusions? Were these designs created for the sheer joy of playing with shapes? Or do they relate to some kind of early religion in Japan, celebrating the creative spirit in nature? Certainly what we know of the Shinto religion suggests that the native belief in deities (kami) that exist in many natural forms began in prehistory, although some scholars believe that kami worship did not arise until after the Jomon period ended. Might the Jomon forms represent the cycles of nature, curling, bending, and twisting to create new and always changing forms?

By 1500 B.C.E., Chinese ceramics were developing in a totally different direction; the use of higher firing temperatures and the addition of glazes gave the works added strength and usefulness. But in Japan, the focus of attention for potters remained visual rather than technical. And there is such amazing variety; some experts have suggested that each Jomon family created pottery for its own use with its own designs.

Whatever its artistic purposes, Middle

Jomon pottery is unlike any other in the world, and represents a high point of artistic flamboyance in prehistoric Japan. But pottery was not only a medium for vessels; small figurines created in the Middle and Late Jomon eras also show both great variety and a mysteriously animistic sense of artistic vision (see figure 11). We can only guess, or try to empathize, with this vision today, but that it existed is proven by the many extraordinary works still remaining from the Jomon period.

Historians differ on exactly what forces combined to bring the end of the Jomon era and the beginning of the succeeding Yayoi period (c. 300 B.C.E.–C.E. 300). One important factor was the development of rice cultivation. The kind of community organization necessary for rice farming stimulated the development of larger-scale settlements, eventually leading to the beginnings of a stratified, class society. The change was probably influenced by the arrival of peoples from the Korean peninsula, who brought with them a language that is considered the basis for what has evolved into modern Japanese. The Yayoi people also developed the use of bronze, both for weapons and for ceremonial bells. At one time, the Jomon- and Yayoi-era peoples were thought to be completely distinct, but it is now believed that there was considerable interaction and interdevelopment between the two. However, the life-styles and artistic ideals were quite different between the two eras, and we can see how changes in ceramics marked an important development in Japanese history.

At first, Yayoi vessels may seem very plain compared to the marvelous elaborations of Jomon ceramic forms. However, Yayoi pottery has its own beauty, a harmony of form and firing that can be very satisfying in its own artistic terms. Fine alluvial clay from riverbeds and deltas was now utilized so that thinner-walled, more delicate shapes could be formed and fired than ever before.

The Yayoi pots that are illustrated in Japanese art books often have either external decorations or red slips (or thin outer layers) of clay that were burnished to give them a rich glow. While these can be beautiful, they do not represent the typical pots of the era. Most Yayoi vessels were unadorned; what was considered most important was the graceful shape and balance of the form itself, to which firing marks could add natural colors of black and red in irregular patterns. This combination of shape and firing marks allowed a mixture of artistic and natural features in the finished pottery, a combination admired by many Japanese potters of the present day.

One work more typical of Yayoi pottery than most published examples is a vessel with a small foot, rounded body, and well-proportioned (now slightly broken) lip (figure 2). The aesthetic of this pot comes first from the balance between the foot, body, and lip. We can ask ourselves how it might have been different. Would a larger foot have helped or hurt the total form? What if the body were more slender? How about a different lip: smaller, larger, or moving up and out at another angle? Clearly, each small change would have made a great difference in the beauty of the pot.

The second important aesthetic factor in this Yayoi pot is the slight upward thrust of the total shape. The body is not quite round, but slightly oval, avoiding any feeling of heaviness or sagging. This form of Yayoi pot seems to reach up, to breathe, with a sense of life.

These two factors of balance and slight upward thrust were created completely by the potter, but the final factor in the aesthetic depended in part on nature. Firing marks could be controlled to some extent by how the pot was placed

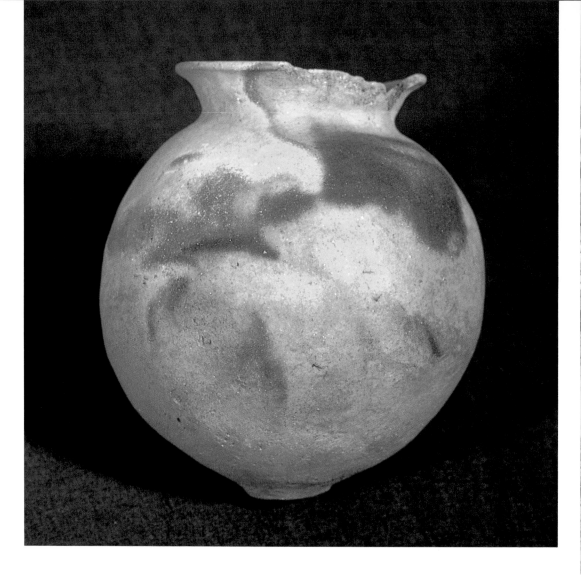

2. *Yayoi Pot*. 1st–2nd century.
Earthenware, height 11″
(27.9 cm). Private collection

in the firing ditch and how it was covered with
wood, but the total result could not be known
until the firing was complete. Additional marks
might also come from use, when the pot was
being heated in an open fire. The firing marks
visible in figure 2 may suggest abstract shapes,
drifting clouds, or whatever else the viewer may
see in them. The important point is that they cre-
ate designs that enliven the surfaces.

Yayoi potters must have known that their
originally plain surfaces would naturally gain

visual interest from firing and use. In fact, the burnishing of red slip over the bodies of some vessels may have been an attempt to control the colors, so that the potter did not have to depend entirely on firing marks for surface decoration. But for many viewers, the natural marks of the fire are an aesthetic point of beauty, and some Yayoi ceramics have never been surpassed for the harmony between their shapes and the designs created from firing and use.

Medieval to Early Modern Stoneware

Japan has gone through several major transformations over the ages. The transition from Jomon to Yayoi was one, and another has been the frenzied Westernization of the last century. The most important series of changes, however, occurred in the sixth and seventh centuries, when the importation of Chinese and Korean cultures brought Buddhism, a writing system, and new forms of government, medicine, and art to Japan. The increased sophistication, combined with a centralized government, gradually led to a highly developed culture dominated by the Imperial court. As we shall see in later chapters on sculpture and painting, international styles were assimilated in Japan to create new modes of artistic expression. More technically advanced forms of pottery were also adopted, including Chinese-style three-color lead glazes on earthenware; higher-temperature firing techniques from Korea that created stronger vessels (called stoneware); and a greater range of shapes than ever before. However, the genius of the native Japanese tradition, with its great respect for both the clay and natural firing patterns, was never entirely lost.

As the era governed by the court was supplanted by warrior dominance of Japan in 1185, highly colorful and decorative forms of art de-

clined in importance, and a simpler, more austere aesthetic developed. This was partly due to warrior taste, and partly influenced by Zen Buddhism. The ceramics of the medieval Kamakura and Muromachi periods (1185–1568) are characterized both by their strength of form and by the natural-ash glazes that make each piece different from the next.

It must be remembered that the Japanese have not always eaten from plates. Instead, before the modern period, people of higher classes often ate from lacquer bowls, while those who could not afford lacquer used wooden dishes as well as pottery plates. Ceramics, however, were still absolutely necessary for cooking and storage, just as they had been in the Jomon period. The finest medieval ceramics include storage jars made at what are known as the "six old kilns" (whose number has now expanded to more than thirty as the result of twentieth-century research). These rural kilns in different areas of Japan produced pots and jars with local clays that show fascinating regional characteristics.

One of the most famous local kiln areas has been Shigaraki, located in Shiga Prefecture not far from Kyoto. Shigaraki clay, which comes from the ancient bed of Lake Biwa, is sandy and coarse, sometimes leaving tiny cracks as it dries. The clay holds trace metals that can cause it to fire into a rich red-orange; it also contains tiny particles of feldspar. During firing, these are usually pushed to the surface, where they leave tiny white explosions called "stars" or "crab's eyes." At higher temperatures, many of the feldspar particles melt, leaving tiny pits called "stone bursts." Surface decoration thus results from the nature of the clay and the firing, rather than from a deliberate artistic process such as the application of glaze.

Perhaps the most characteristic ceramic vessel shape from the medieval period is the *tsubo,* a

narrow-mouthed jar for storing seed. Over the centuries, the basic *tsubo* shape gradually changed; many viewers prefer the powerful, slightly irregular shapes of the earlier examples to the later, more symmetrical vessels. One impressive work dating to the fifteenth century (figure 3) was clearly built in four main stages, with the potter letting the clay harden somewhat before going on to the next coil-built layer. The mouth, now slightly broken, was the last section to be added.

What are the qualities to be admired in this plain and rough *tsubo*? The first thing we notice is the bold strength of the form, rising from its modest base to high shoulders that curve quickly inward to the small mouth. Almost as important is the texture of the clay, with many white particles of unfused feldspar dotting the surface like stars in a sunset sky. Also remarkable is the rich, organic orange color that results from the trace metal elements in the clay. Finally, the touches of natural green glaze on the lip and one side are the result of the wood ash vitrifying (or fusing) in the heat of the kiln and melting irregularly on the *tsubo*.

Ultimately, the beauty of this pot comes from the combination and balance of all of these elements that so clearly reveal the potter's understanding of natural materials. The *tsubo* is nothing more than fired clay, with no applied glazes to hide its basic materials, and it derives much of its beauty from elements such as trace metals and feldspar. However, as with much Japanese art, the sense of naturalness has been brought to the fore by artistic means; the pot has been strongly fashioned into a handsome and useful vessel by an anonymous craftsman of the fifteenth century who was well aware of the effects of fire on Shigaraki clay.

It is sometimes felt in Europe and America that so-called functional objects are not art but craft. In Japan, however, a beautifully crafted lacquer, ceramic, or textile is as highly admired as a fine painting or sculpture. It is well understood that all forms of art, whatever the period and style, can be wondrous if we have the eyes to see them. And all art works are functional in some way, or they are quickly forgotten.

It has been argued, by Yanagi Soetsu in his book *The Unknown Craftsman,* that the unselfconscious works of traditional crafts are higher forms of art than the "aesthetic" creations of professional artists, who were in effect seeking to sell themselves as well as their works. Do you agree? This attitude would seem to turn our values upside down. Can rural pottery be more valuable than paintings by well-known artists? It would certainly have amazed medieval Shigaraki potters to know that some pots and bowls they made for daily use can sell for several hundred thousand dollars in the late twentieth century.

Among the first Japanese to admire medieval ceramics as works of art were tea experts of the sixteenth and seventeenth centuries. The influence of Zen helped to shape the practice of drinking powdered and whisked green tea in a small room with one or two close friends. Not only tea jars and tea bowls, but also tea caddies, water jars, and sometimes vessels for small portions of food were needed in *cha no yu*—called the "tea ceremony" in English, although the Japanese phrase means only "hot water for tea." The quiet and refined drinking of tea, influenced by the spirit of Zen, was a respite from the noise,

Opposite:
3. *Shigaraki Tsubo.* 15th century. Stoneware with natural ash glaze, height 21¼" (54 cm). Asian Art Museum of San Francisco. The Avery Brundage Collection (B66. P38)

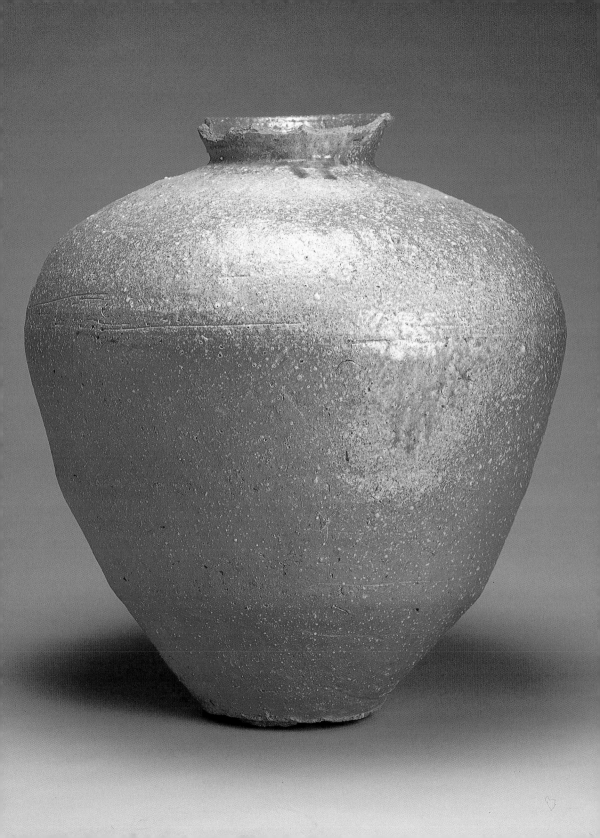

bustle, and cares of the world, and the tea aesthetic of *wabi* ("lonely"), *sabi* ("astringent"), and *shibui* ("understated") was well suited to the restrained natural beauty of unglazed ceramics. Not only were vessels from Shigaraki and other medieval ceramic centers prized, but the leading tea master of the sixteenth century, Sen no Rikyu (1522–1591), also helped to design tea bowls that were crafted by his friend Sasaki Chojiro (1516–1592). Chojiro's son, also an excellent potter, was awarded a seal, reading *raku* ("pleasure"), by the Shogun (military leader of Japan), and in this way *raku* pottery was given its name.

Chojiro's *raku* tea bowls are sometimes considered the ultimate Japanese ceramics. Modest in shape and undecorated, they fit well in the hand, conveying the warmth of the hot tea. Handcrafted without the use of a wheel, the bowls are slightly irregular in shape, but they usually have a small, round foot and sides that are almost straight except for very subtle indentations about halfway up. In *raku* technique, the ceramics are low-fired and plucked from the kiln while still hot. The tonality and texture of the bowls depend on the rapid cooling of the clay.

Since each of Chojiro's tea bowls has a personality all its own, each has been given a name. One of the finest is called *Ayame* (figure 4), a word that can mean a flower of the iris family, or a pattern or design, or that can even suggest the idea of being wounded. Here, a slightly reddish brown mixes with black to give a subtle but constantly changing color and texture to the tea bowl. Nevertheless, many viewers not accustomed to Japanese taste might find this tea bowl boring. How can it be praised as a masterpiece of Japanese art?

Like most ceramics, *Ayame* does not give more than a suggestion of its beauty in a photograph; it must be held and "seen with the hands." Picture yourself sitting in a rustic tea

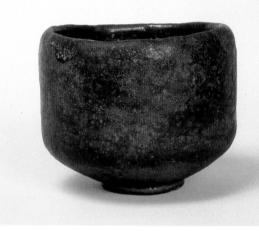

4. Sasaki Chojiro (1516–1592).
Raku Tea Bowl, "Ayame." Earthenware, height 3½" (8.9 cm).
Hakone Museum of Art

room, holding the bowl and feeling its warmth with your left hand, turning it with your right hand, inhaling the aroma of the tea. A few quiet sips, a sense of serenity, and the appreciation of natural form and beauty all help to make this a rich artistic experience in which the *raku* bowl plays a large part.

Raku ware has remained celebrated for four hundred years, continuing to be made by generation after generation of the same family. The current *raku* master always sells out his extremely expensive tea bowls on the first day of his exhibitions. Can we conclude that the Japanese taste in ceramics shows a preference for quiet shapes, modest colors, and restrained designs? Yes, but then again, no. As in other forms of Japanese art, the most understated is often juxtaposed with the most brilliant, the most subtle with the most overt.

The tea ceremony has had a vital influence on many ceramics, usually but not always in the

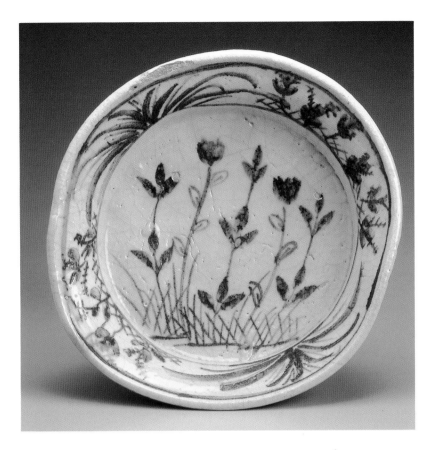

5. *Shino Plate*. c. 1600. Glazed stoneware, largest diameter 14¾″ (37.5 cm). Asian Art Museum of San Francisco. The Avery Brundage Collection (B66. P37)

direction of simplicity and modesty of design. One form of pottery that displays a more overt beauty is *shino,* a name that might have come from the Japanese word *shiroi* ("white"). Created in the ceramic center of Mino, *shino* reached the height of its beauty during the brief but brilliant Momoyama period (1568–1600).

Some historians have called the Momoyama era a Japanese renaissance, because of the revival of early traditions, the large-scale architecture of palaces and temples, and the brilliance of the art. Japan was now ruled by a series of powerful Shoguns who reunited the country after a century of civil wars. The quiet and rustic tea ceremony was emboldened with new drama and splendor; one Shogun even invited the entire populace of Kyoto to a grand tea ceremony, lining the walks with a hundred pairs of golden screens. While some cultural historians have felt that this extravagance lost the original spirit of *cha no yu,* it cannot be denied that the new era gave a fresh impulse to many arts and artists.

Shino pottery displays the rich decorative beauty admired in the late sixteenth century while retaining a pleasing sense of naturalness. One splendid example of Momoyama style is a large *shino* dish with designs of flowers and plants (figure 5). The vessel was first shaped, then allowed to dry and painted with a design. This was covered irregularly with a glaze made

primarily from feldspar and wood-fired in a hill-side kiln. During the firing, the glaze turned white, crackled, and slightly puddled and pitted, so that the painted design appears unevenly through the creamy richness of the glaze.

Compared with *raku,* is this *shino* dish easier to appreciate, because of its painted design? Or is it easier to dismiss, because of its seemingly unsophisticated manner of painting? If we examine the dish more carefully, it becomes a study in subtle asymmetry. At first glance, the design seems regular, with five flowers arranged in the center in an alternating A-B-A-B-A pattern. But no two flowers are the same height, and the leaves and blossoms are all slightly different from each other. For example, the second flower from the left has four leaves, the second from the right only three, and even the ground line under the grasses is irregular. In the border, the leaves extending sideways do not begin at the exact top and bottom of the dish, but grow from positions (if the dish were the face of a clock) of 5:00 and 11:00. The overall shape, neither round nor oval, also displays an irregularity of form that makes it a unique work of art.

In many countries, symmetry and perfection are admired in the patterns and designs of decorative arts. Not so here. For a Japanese viewer, its asymmetry gives the dish a sense of life. Similarly, instead of the irregular thickness of the white glaze being considered a defect, it is admired as adding "breath" and energy to the form. The fine crackle and occasional pitting and puddling of the glaze also contribute to the sense of personal character.

The cracks, as described to me by Abijah Reed, are caused by different amounts of thermal expansion between the body material and the glaze when the ceramic is fired. As the work cools, tensile stress on the surface is relieved by the development of crack patterns. Since tensile stress is greatest in a direction parallel to the existing cracks, new cracks appear across from them, creating an ever-changing web of angular linear movement. On *shino* vessels, these subtle cracklings often go unnoticed, since the forms, designs, and glazes are more dramatic, but they represent one more way that Japanese artists utilized a natural effect for its aesthetic potential.

Momoyama *shino* wares, such as this plate, are unique in their combination of sensuous decorative beauty and naturalness. When kilns were enlarged and technically improved in later decades, the works lost some of their direct and unaffected beauty. Many excellent potters have continued to make vessels in *shino* style to this day, but none has surpassed the ceramics of the late sixteenth century.

Decorated Stoneware and Porcelain

With the stabilization of the Japanese government in the new capital of Edo (now Tokyo) under the Tokugawa family Shoguns, the Momoyama period gave way to the Edo period (1600–1868). This was primarily an era of peace and prosperity under strong, sometimes repressive, governmental control, during which Japan cut itself off from the outside world. Instead of the arts stagnating, however, they flourished as never before. Many forms of ceramics were produced, ranging from understated tea wares to colorful porcelains. While the grandeur of the previous Momoyama era was never quite matched, some remarkably dramatic designs were invented for decorated ceramics in several different kiln areas.

After the Momoyama period, taste in tea ware remained primarily for the subtle rather than the bright or colorful, and the aesthetic of *shibui* prevailed. However, for the serving of food at a formal *cha no yu,* more decorative ceramics were sometimes used. With their love for asym-

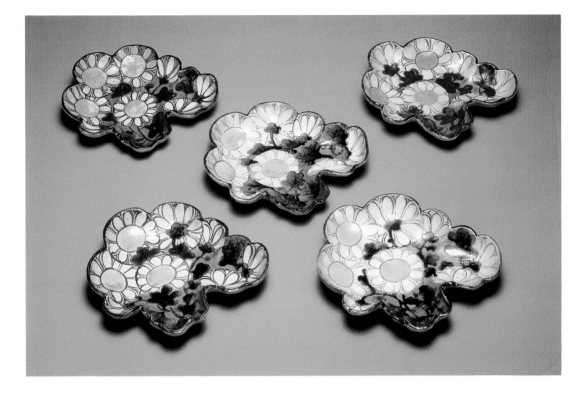

metry, the Japanese have made sets of dishes in groups of five rather than four, six, or eight. An even number of plates, each the same shape and design, still seems tedious to Japanese connoisseurs, who couldn't imagine ordering a huge set of dishes, all round and all similarly decorated.

Let's examine one set of five dishes designed by Ogata Kenzan (1663–1743), Japan's most famous potter of the Edo period. Using special stoneware clay, Kenzan not only painted chrysanthemum designs in bright overglaze enamel colors, but also shaped the dishes like small groups of flowers (figure 6). Chrysanthemums were symbols of autumn, and so these plates suggest the joys of the fall season as well as the transient nature of beauty. They would have been used during a tea ceremony for small portions of food, and their lively colors and irregular shapes

6. Ogata Kenzan (1663–1743). *Set of Five Dishes*. Stoneware with overglaze enamels, largest diameter 7⅝″ (19.4 cm). The Gotoh Museum, Tokyo

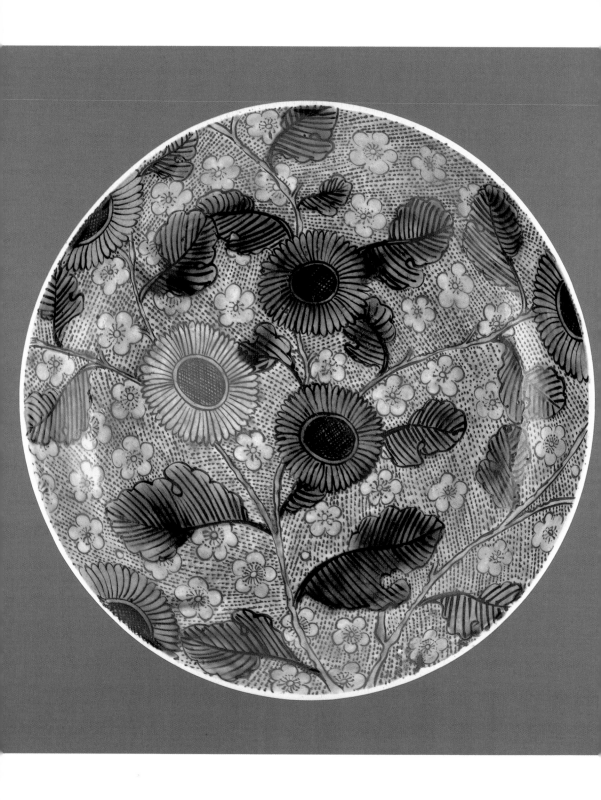

would create a pleasing contrast to a modest and *shibui* tea bowl.

Kenzan was a well-educated aesthete interested in painting, poetry, and calligraphy. He is now considered one of the greatest artists of the decorative Rinpa school of painting, along with his brother Ogata Korin (see figure 33). It is questionable how many of his works Kenzan actually potted; he hired workers who probably did most or all of the forming of the pieces. However, in the creativity and range of his designs, Kenzan was unlike any potter before him. He made a great variety of vessels in many different shapes and styles, and his designs include not only overglaze enamels such as in these dishes, but also splendid underglaze paintings in iron washes.

Kenzan became so popular that there has been a great demand for his works, leading to a number of both followers and forgers. While scholars struggle to determine which works are authentic, Kenzan has become more than an individual artist of a particular era. In both Japan and the West, the name Kenzan has come to stand for certain kinds of high-quality decorative pottery, whether they were designed and decorated by the master or not. This is perhaps the ultimate compliment a creative person can receive, and it also demonstrates that the most celebrated individual in the history of Japanese pottery is now among the most famous names in world ceramics.

Opposite:
7. *Ko-kutani Platter*. 17th century. Porcelain with overglaze enamels, diameter 13¾″ (34.9 cm). Los Angeles County Museum of Art. Purchased with funds provided by the Art Museum Council

Some of the acclaimed porcelains of the Edo period are called *ko-kutani* (Old Kutani). But where were they made? According to traditional accounts, the lord of the Maeda clan in northwestern Japan desired to create a porcelain industry in his domain that could produce colorful ceramics in Chinese Ming-dynasty style. Therefore one of his retainers went to the pottery center of Arita in Kyushu—the southernmost island of Japan—married into a porcelain-making family, and learned the secrets of the technique. He then deserted his wife and returned to northwestern Japan about 1655 to build a kiln in the mountain village of Kutani. Supposedly, brightly colored *ko-kutani* wares were then manufactured in this village until the early eighteenth century, when production ceased until a pottery revival a century later.

The problem with this account is that excavations have revealed no traces of *ko-kutani* shards in Kutani, and now many scholars believe that the wares were actually ordered by the Maeda lord from potteries in Arita. But legends die hard; the name *ko-kutani* is still commonly used for a style of seventeenth-century porcelain with strikingly bold and imaginative designs, frequently utilizing a special range of colors in overglaze enamels.

The most admired works in *ko-kutani* style are large plates, strongly formed and fully decorated. One of the finest examples is a large plate with bold chrysanthemum designs over a yellow ground of cherry blossoms and freely painted dashes in varying linear rhythms (figure 7). The green chrysanthemums are also rather linear, with long ovals for the petals and parallel lines in the leaves. Their gently curving stems are painted in aubergine, which, along with yellow and green, is one of the colors most associated with *ko-kutani*.

Compare this to Kenzan's dishes: the anony-

mous *ko-kutani* artist has modeled the chrysanthemums into the shape of the plate, while Kenzan modeled his dishes into the shapes of chrysanthemums. But there are other kinds of creativity at work here; combining autumn chrysanthemums with spring cherry blossoms is one of several playful touches of this potter-artist. Another is the unusual play of forms. The overlappings of flowers, leaves, and blossoms, which should produce a sense of depth, are incongruous with the deliberately flat renditions of green flowers and yellow blossoms. However, the moment of special genius in this design comes when the anonymous artist chooses to leave one chrysanthemum yellow, rather than the rich green of the other flowers. This breaks up the rather symmetrical tripartite arrangement of the design and adds a note of surprise and humor that enlivens the plate and makes it unique.

Whether or not *ko-kutani* was made at the ceramic center of Arita, many other porcelains were certainly crafted there, including the wares that were then shipped from the port city of Imari and sometimes called by that name. The most popular porcelain tradition in Arita was one directly borrowed from China and Korea and is usually called blue-and-white. The earliest potters to develop this tradition in Japan were Korean immigrants in the early seventeenth century; the Korean influence in Japanese ceramics has been vital at many stages of Japanese history.

Blue-and-white soon became as popular in Japan as in China and Korea, and as it was to become in the Western world. The combination of the pure white color of porcelain with the elegance of underglaze designs in cobalt blue has been almost universally admired as perfectly suited to food dishes and cups of all kinds. Since blue-and-white was not an indigenous Japanese tradition, it was somewhat transformed in Arita (and other porcelain centers) to suit Japanese

taste. New subjects were depicted, the underglaze designs were often more freely sketched than in Chinese examples, and the plates were made in varied shapes to suit the Japanese delight in serving a meal in many different kinds of dishes. Ultimately, the large-scale production of blue-and-white porcelains helped to lead to the full use of ceramics for dinnerware in Japan.

It is sometimes difficult to date Japanese blue-and-white wares because their production has been so continuous from the early seventeenth century to the present. However, the precise age of a vessel may be less important than its quality and charm. Semi-translucent white porcelain, high-quality potting, fine cobalt blue, and lively underglaze painting are all elements in the appreciation of this ware.

A single photograph can show only some of the many sizes, shapes, and design motifs that have been made in recent centuries (figure 8). Many are circular plates and bowls with either plain or scalloped edges, but rectangles, ovals, diamonds, and other shapes were also made for a sense of variety. Of course, much larger plates and bowls were made than those shown in this photograph, but we can still see great differences in the sizes of the dishes. The landscapes, orchid, and grape designs here are Chinese in origin, but the fish and especially the mouse are more typical Japanese motifs. Some of the underglaze paintings echo the shapes of the dishes, such as the circling fish, the rounded grape leaves, and even the horizontal landscapes. Occasionally, however, the designs form a contrast or counterpoint to the vessel shape, such as the orchid's bending leaves, the almost triangular mouse, and especially the vertical human figure.

More than in other cultures, visual elements are crucial to Japanese cuisine. Strict attention must be paid to serving the appropriate foods for the season, with lively combinations of colors

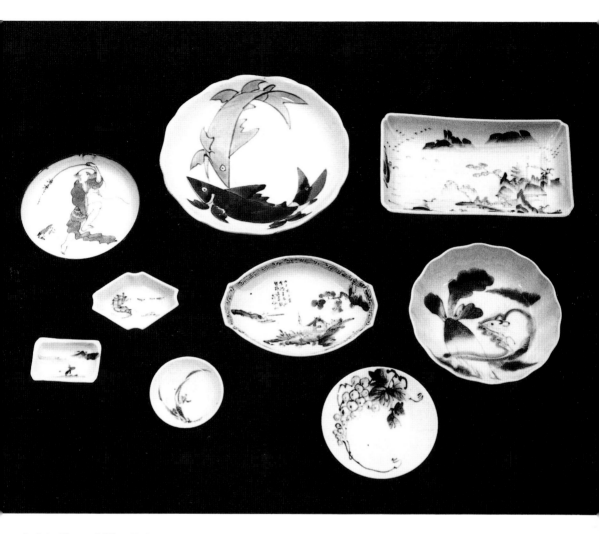

8. *Arita Blue-and-White Dishes.*
18th–19th century. Porcelain,
various sizes. Private collection

and textures. Cuisine aesthetics also include the creative use of ceramics, in which not only different shapes but also the rough and smooth textures of stonewares and porcelains are alternated in accordance with the foods being served. Might the taste for such varied vessels change our own ideas of how to serve a meal?

Modern Japanese Ceramics

The forced opening of Japan to the West led to the end of the long-lasting Edo period and the beginning of the Meiji era (1868–1912), in which major changes occurred in almost every aspect of Japanese life. The tide of influences from Europe and America threatened to engulf all indigenous traditions, but in some areas Japan soon discovered itself far ahead of the West. One of these was ceramics; the Japanese influence on European and American pottery during the past century has been immense.

Because of Japan's high level of artistry, traditional potters were able to continue to create their wares in the new era without disruption. In the early Meiji period the Buddhist nun Otagaki Rengetsu (1791–1875) made pottery vessels inscribed or engraved with her lyrical poems, tensile calligraphy, and sometimes even small paintings (see figure 46, page 90). Her works combine several arts in a characteristic Japanese manner, making it difficult to decide whether they should be considered ceramics, poetry, calligraphy, or painting. During the period when she created her unique works, other potters continued established traditions such as *raku, shino, ko-kutani*, and blue-and-white. Many of these were shown at international expositions in the late nineteenth century.

The twentieth century has become one of the golden ages of Japanese ceramics. Perhaps the greatest name is that of Kitaoji Rosanjin (1883–1959), a master of every style who can be compared only to Kenzan in the range and breadth of his talent. Like Kenzan, Rosanjin did not shape all of his pottery vessels, but employed others to do much of the basic "throwing" on a wheel, or hand-forming. But Rosanjin would then give the work a pinch, a bend, or a twist, and it would become alive, ready for one of the many kinds of painting or glazing at which he excelled.

Rosanjin had not intended to become a potter. He was an illegitimate child, and after being passed around from one foster home to another in his youth, he pursued a serious interest in calligraphy as a teenager. However, he quickly developed a lifelong interest in fine food, and in 1925 he opened a gourmet restaurant in Tokyo. Extremely fussy about which dishes he would use, Rosanjin decided to design his own tableware. Before long his plates, bowls, and dishes were being admired by his restaurant patrons, then by their friends and acquaintances, and eventually by all those who valued fine ceramics.

Rosanjin was irascible, and at his restaurant he did not suffer loud or ignorant customers. In 1936, after he found himself forced out of the restaurant by his partners, he said, "I never dreamed it would end this way, but here I am, by God, a potter!" Undaunted, over the course of his lifetime he produced more than twenty thousand ceramics, mostly at his six kilns in Kita-Kamakura.

Since Rosanjin's range of different clays, firing techniques, and glazes covers almost every Japanese tradition, it is difficult to illustrate his work with only one example. However, his use of green ash-glaze is so remarkable that a single square plate can serve to demonstrate Rosanjin's art (figure 9). Its irregularity of shape reminds us once again that asymmetry is a long-established Japanese tradition, while the low ridges running

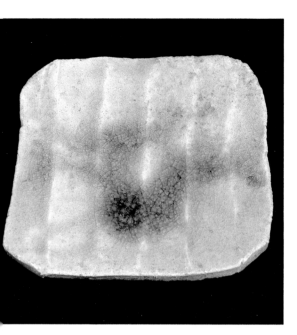

9. Kitaoji Rosanjin (1883–1959). *Iga-style Square Plate*. Ash-glazed stoneware, 7½ × 7½" (19 × 19 cm). Private collection. Formerly Cardozo collection

across the plate add an interesting texture to the form. The green glaze, spreading and crackling unevenly over the surface, is almost transparent and remarkably lustrous. Rosanjin made a number of these plates, each one different and each revealing his genius.

Today, Japanese pottery remains a vital form of art. This is in large part because of frequent exhibitions and an informed public. In contrast to most other countries, where potters have a difficult time earning a living, in Japan there are as many as ten thousand potters successfully producing ceramics as a form of art. Historical and regional traditions flourish, and useful forms such as tea bowls for *cha no yu,* vases for flower

arranging, and plates and dishes for serving food are still highly admired. But innovative ceramic sculpture, influenced by trends from the West, is also flourishing. How are we to judge contemporary Japanese ceramics, when so many artists are creating so many different kinds of pottery?

Let's examine the work of one contemporary potter who takes inspiration from the most basic aspects of the ceramic process. Uematsu Eiji, born in 1949, lives and works in the province of Iga, across a mountain from Shigaraki. Uematsu first studied at an art school in Tokyo and then worked in a ceramic factory in Shigaraki, but his goal was always to discover the natural properties of clay and fire. He digs his own clay, seldom uses the potter's wheel or glazes, and explores basic shapes and firing techniques in a kiln that he built himself.

A rectangular vase demonstrates how Uematsu has been able to rediscover the early Japanese pottery aesthetic in his own work (figure 10). The clay is a mixture of Shigaraki and Iga, with the "stars" and "stone bursts" we saw previously in the medieval *tsubo* (see figure 3). The vase was placed at the base of the kiln so that firing marks from charcoal cover about half the vessel with black, while the other half has been fired to a typical Shigaraki red-brown, allowing "stars" to shine brightly on the surface of the vessel. So far, everything has been traditional, but the shape of the ceramic is new. Built from four slabs of three different heights, the vase seems both basic and modern, resembling an architectural form. The result is controlled and yet free.

Uematsu says that "eighty percent of the finished ceramic is the result of my work; the other twenty percent comes from nature, so I can never predict exactly what the piece will look like when it emerges from the kiln." Because he uses unrefined clay and traditional wood firing,

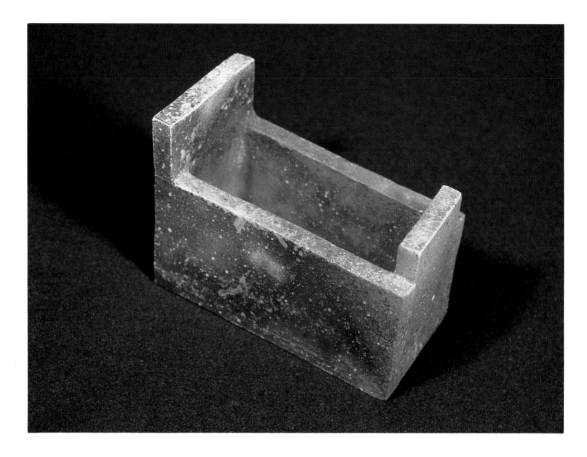

10. Uematsu Eiji (b. 1949). *Rectangular Vase*. Stoneware, height 3⅞" (9.8 cm). Private collection

the colors of the clay, the firing marks, even the shape and bend of the vessel, are transformed in the kiln. This pleases Uematsu, who would have it no other way.

Strangely enough, although Uematsu is living thousands of years after the Jomon era, many features of the pottery remain the same: powerful forms in basic shapes, asymmetry, a strong sense of the clay, little interest in elaborate techniques for their own sake, and a feeling of individuality in each vessel. Among the thousands of skilled potters working today, Uematsu especially well exemplifies the ageless tradition of Japanese ceramics.

Key Questions When Looking at Ceramics

Clay. If the ceramic is not completely covered with glaze, can you see what kind of clay has been used, at least on the base or foot? Does it seem heavy or light? What color is the clay, and how does it harmonize (or contrast) with the glazes or firing marks?

Texture. Is the fired clay coarse or fine, smooth or rough? Is it marked or plain? Does it show traces of the potter's hand? How does the texture suit the shape and purpose of the piece?

Glaze and Decoration. Are there firing marks? Is there a natural or applied glaze? If so, is there underdrawing in iron or another glaze, or overglaze enamel or other decoration? How do the colors and/or decoration suit the shape and purpose of the piece?

Form. Is the shape symmetrical or asymmetrical? Why? Can you tell if it was formed on a wheel? Built of slabs? Coil-built? Hand-formed? Is the base or foot appropriate to the shape of the piece?

Tradition. Does this piece fit into an established tradition, such as *raku, shino*, and so on? If so, how well does it represent this tradition? Is it typical or unusual? Does it show the best features of the tradition, such as the subtle textures of *raku* or the rich naturalness of *shino*?

Tactile Quality. With most Japanese ceramics, the feeling of holding a vessel can be one of its great joys. "Seeing with the hands" is one of the best ways to judge a tea bowl, plate, cup, bowl, or even a vase. When you pick up and hold the piece, what does that tell you about it? Can you sense the purpose of its maker?

Balance. Perhaps the ultimate question in viewing a ceramic is its sense of total balance. Even if the piece is symmetrical, you should still judge the other kinds of balance evident in its thickness, shape, and design. Do you feel that the overall shape harmonizes the bottom, sides, foot, rim, and any other features? Do the clay, glaze, color, and texture add a sense of life?

2. SCULPTURE AND TRADITIONAL BUDDHIST ART

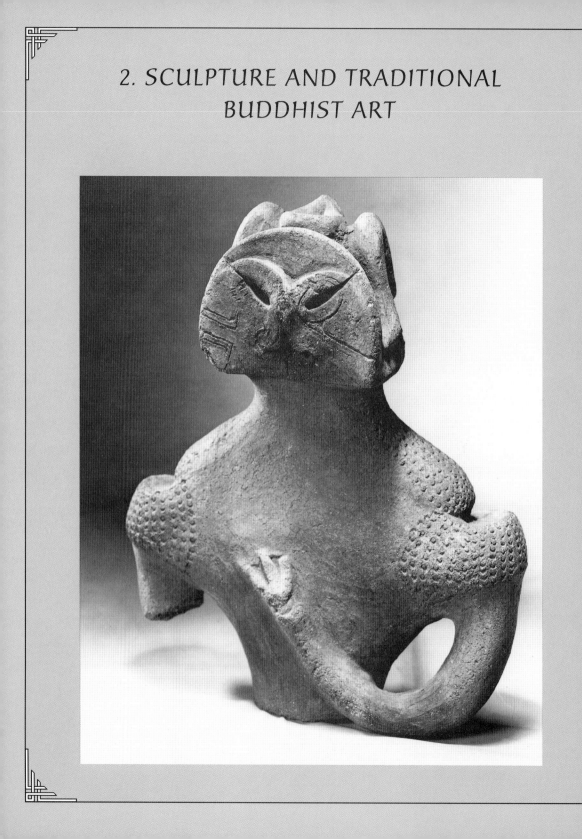

Sculpture, like pottery, is an art in three dimensions, which means that even the finest photographs do not do it justice. Although some sculptures are intended to be seen only from the front, such as works in relief, most are best viewed in the round to understand their total rhythm, which comes from the continuous articulation of forms. In addition, all sculptures should be seen in different lights, and if possible in their original contexts. Most museums fail abysmally at exhibiting them. The works are often placed against a wall, at the wrong height; they are almost always given an unchanging source, color, and intensity of light; and they are usually installed with little or no visual sense of the context for which they were made. Despite these difficulties, Japanese sculpture has been highly admired and appreciated in the West for its power and beauty.

In sculpture as in ceramics, the materials have been vital to the development of Japanese art. Throughout the ages, the sculptors showed their understanding and respect for the different mediums of clay, bronze, stone, dry lacquer, and most especially wood, for which they had a special empathy. Their sculpting shows the respect for materials that is such a strong characteristic of Japanese art.

Opposite:
11. *Jomon Figurine*. Clay, height 10″ (25.4 cm). Tokyo National Museum

Prehistoric Sculpture

The earliest Japanese sculptures were formed from clay. During the Jomon period, semi-abstract and often hauntingly evocative figurines were created. Their purpose is still not known, although there are many theories. People have suggested they were dolls for children, but for that they seem to convey too strange and deep a significance. Others think they may have served as fertility figures, but sexual characteristics are usually absent or understated. The possibility that they were intended as images of deities is weakened by their great variety of shapes, forms, and styles. Since many have been found broken, seemingly deliberately, they may have served to embody a disease, which could then be alleviated by destroying the figure.

Whatever their purpose, or combination of purposes, these Jomon-era figurines are fascinating and often haunting in expression. One of the most remarkable is a mysterious sculpture with a catlike face that was discovered not far from present-day Tokyo (figure 11). We do not know whether the figure is human or animal, male or female, sacred or secular.

Everything seems curved, including the semicircle of the face, the elegant neck, and the strangely notched shoulders. These notches may indicate where a rope could be tied or some decoration affixed, perhaps for a ritual. Or they could suggest some special separation of arms and torso with a symbolic meaning now lost to us.

The raised areas behind the face may indicate a Jomon-era hairstyle. The face is incised with marks that continue on the neck and shoulders, probably made with a bamboo stick. They give the figurine a sense of texture, and they may represent either tattoos or clothing, possibly fur. But they might also have a special meaning now unknown.

One rounded arm holds three fingers against the chest. Again, the purpose of this gesture is unclear. It may suggest some special indication of self. The figure is abstract rather than individualized, however, and the face is very masklike. The German philosopher Friedrich Nietzsche once commented that "all that is deep loves the mask," and throughout history, masks have been used to indicate more profound meanings than any individual face could show. Though this figurine points to itself, it has been abstracted into a creature of mystery.

The Yayoi period produced few sculptures that still survive, but during the succeeding Kofun era (c. 300–552), a great many ceramic sculptures were created for a new reason: to stand on the huge grave mounds of royal personages. Beginning with simple cylinders, these hollow clay sculptures called *haniwa* soon became images of houses, boats, birds, animals, and eventually human figures as well. But what was the real purpose of these figures? Funerary goods made from pottery have been common in many early cultures. They reached a high point of development in China, where ceramic figurines were often buried with the dead, presumably to serve or to entertain them in the afterlife. But *haniwa* were not buried in tombs. Instead, they stood over the grave mounds, facing the outer world.

Some have thought that *haniwa* were protectors of the tombs. Certainly, there are a number of figures of warriors. But why then were there also singers, dancers, shamans, horses, monkeys, and geese? Perhaps *haniwa* were some kind of link between the world of the dead and the world of the living. Since there was no writing system at the time, there can be no contemporaneous documents to explain the purpose of these sculptures. But in purely visual terms, there is no doubt of their artistic strength and integrity.

Among the most dramatic of all *haniwa* are a pair of figures with raised arms and open mouths (figure 12). They seem to be singing, dancing, chanting, or all three together. Since one is taller than the other, they might perhaps represent male and female, parent and child, or teacher and pupil. There are many other possibilities as well, in part because of the extreme simplicity of the *haniwa*. No extra forms, lines, or appendages appear; the clay bodies rise from their cylinders without transition; and detail is subordinated to the total expressive effect. This kind of deliberate simplicity has the power to delve beneath the everyday world into some deeper and more primeval form of expression.

Chinese sculptors of tomb figures tended toward naturalism, producing careful renditions of faces and garments and often adding colored glazes to cover the natural clay bodies of their figurines. The creators of *haniwa* had very different conceptions of their work. They included just enough details to let us recognize that a figure is a monkey, a horse, or a human in a specific pose, but not so many that we can further particularize it. These two chanting *haniwa* figurines can therefore become anyone, or every-

Opposite:
12. *Haniwa Chanters*. Late 5th–early 6th century. Clay, height 25¼" (64.2 cm) and 22¼" (56.5 cm). Tokyo National Museum

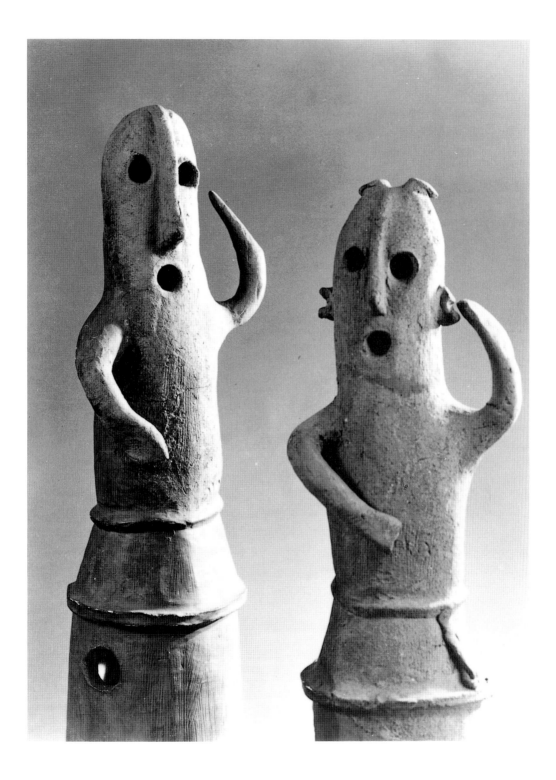

one, and they express a kind of universality that was an integral part of their original context.

To re-create that context, we must imagine a huge hill, surrounded by a moat and covered with dozens of *haniwa* figures. The effect, seen from close range by those allowed onto the tomb hill, and from afar by all others, must have been imposing. Especially from a distance, the lack of detail would be an advantage in the perception of the primary positions and gestures of the sculptures. The *haniwa* animals, boats, houses, human figures, and other subjects would have created a world of their own. Standing on the tomb, they were neither part of death nor of normal human life. The effect was surely magical, and even today when we see *haniwa* out of context in museums and exhibitions, their direct visual power is evident.

Early Japanese Buddhist Sculpture

The introduction of Buddhism in the sixth century was vital to the development of Japanese sculpture. Here, the Japanese transformation of foreign traditions can be seen clearly. Forms and styles that had begun in India and were brought directly from Korea and China became the models that Japanese artists gradually amplified and developed, creating one of the world's great traditions of religious sculpture.

By the time Buddhism reached Japan, it had undergone considerable changes from the era of the historical Buddha, who lived in India during the sixth century B.C.E. Also known as Shakyamuni—or Shaka in Japanese—the Buddha taught his followers that the way to escape the constant cycle of birth, suffering, and death was by awakening from the world of illusion into personal enlightenment. This was accomplished through meditation, during which personal desires and passions could be extinguished.

Shaka was at first considered an enlightened teacher, guiding his followers toward their own salvation, rather than a god. However, by the time Buddhism became widely established in India half a millennium after Shaka's death, people wanted more than a teacher, and Buddhism gradually became transformed into a devotional religion. Believers could pray to the Buddha, and to other enlightened beings (or Bodhisattva) who had vowed to stay on earth until all were saved. Nevertheless, the life and teachings of the Buddha remained the surest guide to personal salvation.

One of the earliest Japanese Buddhist sculptures is the *Shaka Triad* by Tori Busshi, an artist whose grandfather had emigrated from China to Japan in 522 (figure 13). The work has an inscription carved on the back giving the name of the artist and a year corresponding to 623. The style is that of Wei-dynasty China (386–557), and the triad can be compared to stone sculptures of the early sixth century remaining in the Buddhist caves at Longmen, China.

The sculptural triad was not cast to be seen in the round, but presents itself frontally. Shaka, no longer merely a historical teacher but now the resplendent, enlightened Buddha, sits with his legs crossed in lotus position, his right hand raised in a gesture that means "Have no fear." His long earlobes show that he was born a prince, for royal children wore heavy earrings in India, and the protuberance on his head indicates expanded consciousness. His hair is stylized into so-called snail-shell curls, and his garments are simple, befitting a religious leader who gave away all his royal attributes. He has an oval head, almond-shaped eyes, and a peaceful smile. To either side are Bodhisattva, smaller in size to indicate their lesser Buddhist rank, and with him they form a triad that is often seen in Buddhist art.

There was not much attention paid to

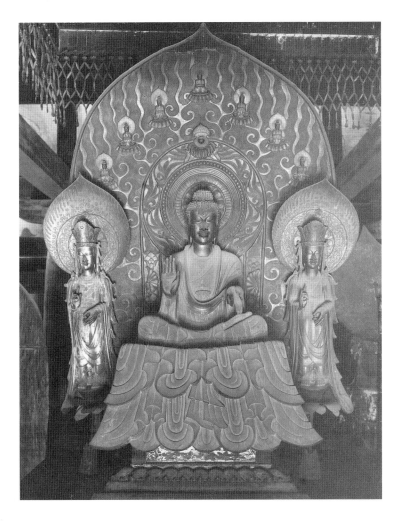

13. Tori Busshi. *Shaka Triad.* 623 (?). Gilt bronze, height 46″ (116.8 cm). Horyu-ji, Nara Prefecture

sculpting the bodies of the figures. The naturalistic Indian style had not yet made an impact in East Asia, and in any event the sensuous forms of Indian sculpture were never entirely accepted in China, Korea, or Japan. What was considered most important is clear from the distortions of relative size: the heads of the figures, which are serene and radiant, and the hands, which teach and reassure, are especially large. The drapery over the dais on which Shaka sits has been given a swirling linear treatment that is remarkable in the bronze medium, indicating that the style might have been transmitted through paintings or sketches. The three figures each have halos in flame shapes; as might be expected, Shaka's halo is by far the most elaborate and contains many smaller Buddha figures. This masterful use of the medium of bronze, until then not highly developed in Japan, must have demonstrated the advanced civilization that Buddhism also represented in its new home.

Buddhist sculpture, like *haniwa,* is impossi-

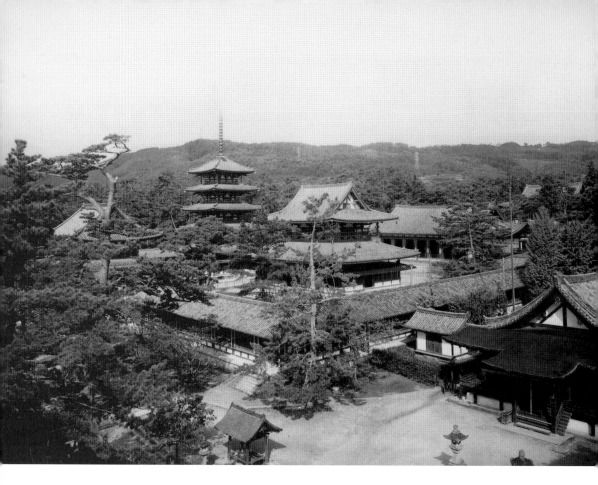

14. Horyu-ji. Late 7th century.
Nara Prefecture

ble to understand fully without being seen in
context. The *Shaka Triad* stands on the main altar
at the celebrated temple of Horyu-ji (figure 14),
near Nara in central Japan. The world's oldest
surviving wooden temple, Horyu-ji was con-
structed in the late seventh century. Relatively
small in size when compared with later Japanese
temples, it is beautifully proportioned with an
unusual asymmetrical design. Instead of the
paired pagodas seen in most later temples, there
is only one, elegant, five-story pagoda, 122 feet
high, which creates an unusual sense of balance

with Horyu-ji's shorter but more massive lecture
hall in the temple compound. The relationship
between the two structures, one more vertical
and one more horizontal, might be compared to
that between the steeple and hall of a Christian
church or cathedral. However, in Buddhist archi-
tecture the two are separate buildings, which
adds tension to the spatial power of the forms.
One reaches to the heavens, the other holds firm
to the earth.

For many hundreds of years, temple pago-
das were the tallest buildings in Japan, simulta-

neously looking over the countryside and beckoning to believers to come, meditate, and worship. But the pagoda could not be entered. Because it was a reliquary for precious Buddhist objects, it could only be circumambulated in veneration. In contrast, the main halls of temples were designed to hold large numbers of believers for Buddhist lectures, rites, and services of all kinds, as well as for personal meditation.

Horyu-ji's lecture hall contains many unique and priceless Buddhist objects, of which the *Shaka Triad* is one of the most celebrated. Horyu-ji and its sculpture were created to represent the glory and power, as well as the compassionate teachings, of a religion still relatively new in Japan.

While the *Shaka Triad* reflects a Chinese stylistic tradition, the wooden statue of Miroku in the Koryu-ji (figure 15) represents a Korean Buddhist style and is made from Korean red pine. The two images show several interesting contrasts, beginning with their differing materials, bronze and wood. Their compositional principles are also different. While the *Shaka Triad* is frontal and evenly balanced, the Miroku is asymmetrical and flowing. Unlike the triad, the single figure can be seen effectively in the round, and in fact every view of it is remarkably beautiful.

As you circle the image, the expression of the face, the relationship of the head to the body, the spacing between the arm and the chest, and the way light moves over the gently undulating forms all create a sense of life and movement. Even looking at a photograph rather than the actual object, its warmth is apparent. This is partly due to the material, for the wood itself seems to be softly glowing. Only traces of color remain, and the natural wood grain adds a subtle sense of texture to the image. The pose of the figure is gentle and relaxed. This posture, with one leg crossed and the fingers of one hand almost

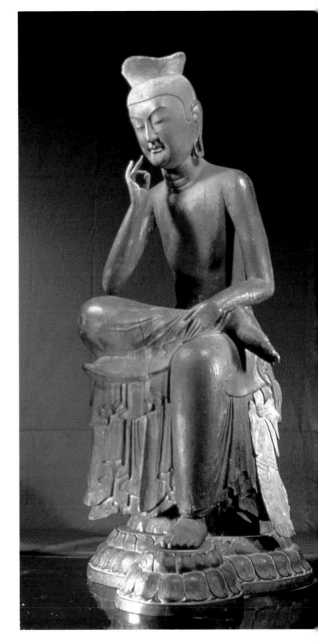

15. *Koryu-ji Miroku*. Early 7th century. Wood, height 48½″ (123.2 cm). Koryu-ji, Kyoto

touching the cheek, can be seen in some of the earliest Indian Buddhist sculptures from Gandhara; it often represents the Buddha in contemplation before he entered his final meditation.

Here, however, the image does not represent the historical Buddha Shaka, but rather the Buddha of the future, Miroku (Maitreya in Sanskrit). According to some Buddhist theology, after a stretch of time during which the Buddhist law would be gradually forgotten, another Buddha would appear to teach salvation. Some people believed that this would occur one thousand years after Shaka's death and entry into Nirvana. Therefore, a strong Miroku cult emerged in parts of East Asia, and because the date of Shaka's death was not firmly established, Miroku remained a popular image for several centuries.

Ultimately, the power of the image rests with the quality of the sculpting that brings forth a sense of peace and compassion. The simplicity and strength of the pose are reinforced by the clarity of the carving, in which there are no frills or unnecessary details. The curve of the chest, the slight swell of the shoulder, the movement of the wrist, the curve of the fingers, the contemplation on the face—these are all suggested more than rigidly defined, and one feels a living sense of breath (called in Sanskrit *prajna*) in Miroku's chest. The result is a sculpture, both spiritual and humane, that has warmed and quieted the hearts of viewers for thirteen hundred years.

Another of the most personally appealing of all early Buddhist sculptures is the remarkable portrait of Ganjin (Chien-chen in Chinese) (figure 16), a Chinese monk who came to Japan in 753 in order to teach and sponsor the proper Buddhist rites of ordination. Ganjin had attempted to travel to Japan a number of times before succeeding, and he had to overcome many difficulties, including official displeasure in China, shipwrecks, and even going blind, before

he finally arrived in Japan. In a recent historical novel, translated into English as *The Roof Tile of Tempyo,* Yasushi Inoue tells the story of Ganjin's adventures and paints a fascinating portrait of eighth-century Chinese and Japanese life, culture, and religion.

Ganjin had originally been invited to help celebrate the completion of Japan's largest temple, Todai-ji. Since his extraordinary difficulties made him several years late, another great temple was constructed for him in Nara, called Toshodai-ji, where his portrait sculpture now remains. This image, from either 763, the year of Ganjin's death, or shortly thereafter, was created in an early dry lacquer technique. First a wooden model was made and covered with clay. Next, successive layers of linen were soaked in lacquer, smoothed over the model, and allowed to dry. When the work was almost complete, the original model of wood and clay was removed from the inside, and a wooden bracing was substituted to support the sculpture. It was then covered with one final layer of lacquer mixed with sawdust, flour, and powdered incense wood; when this was dry, the figure was painted. This technique, in the hands of a master, could produce works that were light, strong, and realistically modeled, but it was so painstaking that a simpler method was devised for later lacquer sculptures.

What has most impressed viewers about this object is its remarkable presence; we feel we are seeing both the outer form and the inner being of Ganjin. The style is in fact not fully naturalistic, since a number of simplifications have been made in order to express the spiritual presence of

Opposite:
16. *Ganjin.* c. 763. Painted lacquer, height 31¼" (80.6 cm). Toshodai-ji, Nara

the blind teacher. But the anonymous sculptor worked so beautifully in his difficult medium that we seem to come face-to-face with this Chinese monk whose enlightenment went beyond conventional understandings of vision.

Esoteric and Pure Land Buddhism

For a number of reasons, including the growing secular power of the Buddhist clergy in Nara, in 794 the government moved the capital to Kyoto (then called Heian-kyo). It was to remain there throughout the Heian period (794–1185). During these almost four hundred years, the Imperial court dominated Japanese aesthetics, maintaining an extremely high standard of taste, sensibility, and refinement. Great masterpieces of secular poetry, literature, and painting were created (see figures 24, 25, pages 54–57), but Buddhist art also reached a high point of strength and beauty.

As the Heian period began, two great monks who had gone to study in China returned to form new sects of Buddhism in Japan. Kukai (also called Kobo Daishi, 774–835) founded the Shingon sect, and Saicho (767–822) founded Tendai Buddhism, both in the beginning of the ninth century. The two sects are esoteric (tantric) in nature, reflecting renewed influences into East Asian Buddhism from India and Central Asia. Esoteric Buddhism is marked by elaborate rituals at which believers attempt to reach salvation through identifying with Buddhist gods and assuming their spiritual powers. Instead of the historical Buddha Shaka, these sects venerate a great number of deities, the foremost of whom is the ultimate Buddha Dainichi, whose name means "Great Sun."

In order to teach this complex form of Buddhism, Kukai brought back to Japan painted mandalas, cosmic diagrams of the spiritual uni-

17. The center of a Japanese mandala

Opposite:
18. *Fudo Myoo*. c. 839. Painted wood, height 68¼″ (173.4 cm). To-ji, Kyoto

verse. Dainichi is placed at the center, surrounded by Buddhas, Bodhisattvas, esoteric symbols, and a multitude of other images. Figure 17 shows the center of a Japanese mandala, with Buddhas of the four directions and four Bodhisattvas circling Dainichi like the petals of a lotus. This lotus form itself is an important Buddhist symbol—rising up from the muck at the bottom of a pond to bloom in fresh purity.

In addition to the proliferation of images in esoteric Buddhism, many tantric deities have fierce as well as serene manifestations. Therefore, Dainichi can also appear as Fudo, the unmovable protector of Buddhism, who holds a sword and a coiled rope to thwart all its enemies. In the lecture hall of To-ji, Kukai's major temple in south-

ern Kyoto, a three-dimensional mandala depicts the most important esoteric Buddhist gods in larger-than-life sculptures. In the center is Dainichi, surrounded again by Buddhas of the four directions. To the viewer's left is the sculptural group of the fierce Five Heavenly Kings, with Fudo at the center (figure 18). Carved around the year 839, almost entirely from one block of wood, Fudo is seated in a halo of flames, his hair in a single braid. He is awe-inspiring, but despite his threatening appearance, does he truly strike fear into the heart of the viewer?

Perhaps not; Fudo's expression seems to mix fierceness, thoughtfulness, and sadness. Yet his power and size are apparent, even in a photograph; the smooth carving of the body is not overly complicated by details, and the strong vertical of the sword contrasts with the softer curves of his shoulders, knees, head, and hair. Fudo's scowl (with two little tusks showing) makes it clear that he is displeased with the world he sees before him, a world full of the suffering caused by human illusions and greed. Yet for Buddhist believers, Fudo represents protection and strength, and he was to remain an important and powerful image of Buddhism in the centuries to come.

While the two esoteric sects dominated the first two centuries of the Heian period, it was another form of Buddhism that was to become most significant in the eleventh and twelfth centuries. Esoteric rituals, no matter how powerfully absorbing, were extremely complex and could not answer all the religious needs of the Japanese populace. Therefore a form of religion called Pure Land Buddhism, based on pure faith and the chanting of a single prayer (or mantra), reached a great wave of popularity.

Among the many Buddhas, each with special powers and attributes, Amida Buddha was the

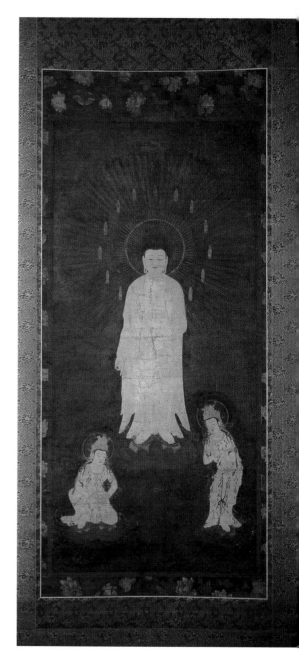

19. *Amida Raigo.* c. 1275. Colors, gold paint, and cut gold on silk, 50¼ × 22⅛″ (127.6 × 56.2 cm). Private collection

principal deity of the Pure Land sect. It was believed that Amida presided over the "Pure Land" of the Western Paradise, where souls of believers could be reborn after death. To reach this paradise, one should lead a good Buddhist life, but even the worst sinner could be saved by simply chanting with perfect faith the mantra *Namu Amida Butsu* ("Praise to Amida Buddha"). Evangelist preachers went through the countryside teaching this mantra, sometimes with song and dance, and large numbers of people were converted. Even today in Japan, Pure Land Buddhism has more members than any other sect.

Art expresses belief. The two main images in Pure Land Buddhism are, first, Amida Buddha coming down to earth to carry up the soul of the dying believer and, second, the Western Paradise itself. The descent to earth of Amida was expressed in paintings called *raigo* ("welcome arrival") that achieved great importance in Japan. One form of *raigo* painting, with Amida directly facing the viewer (figure 19), was often taken to the house of someone near death. The dying believer could hold cords attached to the painting so that his or her soul would be carried directly up to paradise.

Amida, the Buddha of light, radiates a golden glow. In this *raigo,* Amida, standing on a cloud and surrounded by small Buddhas, is also merciful, looking out toward the believer with an expression of serenity and compassion. Below, the Bodhisattva Seishi leans forward with hands clasped in a gesture of welcome, while the Bodhisattva Kannon kneels down to offer a lotus pedestal on which to carry the soul to the Pure Land. Against the dark blue background, these images of Amida and two Bodhisattvas were first painted with gold and then covered with thin filaments of gold leaf, as were the lotus flowers on the inner border. This image, wondrously radiant in the flickering light of oil lamps and candles, would help to inspire the belief of the living and would also give comfort to the dying.

There are many possible ways to portray a god that artists had to consider; should the deity look beautifully human, or more universal and transcendental? As we can see in Buddhist sculpture and painting, the depiction must follow the beliefs of the sect and the purpose of the image. Artists have also had to try to visualize and portray the specifics of heaven or paradise, which is not an easy task. How can you show perfect spiritual peace and joy? The result has to depend on what is most admired on earth, which in Japan seems to have involved a combination of a temple and a palace. In the eleventh century, one of the great Heian court nobles donated his country palace to serve as a Pure Land temple. Located in the Uji mountains near Kyoto, it was re-created to become an image of the Western Paradise. The Byodo-in (figure 20), also called the Phoenix Hall, was dedicated as a temple in the year 1053.

The Byodo-in was constructed with light, thin, and elegant forms, and a pond, dug in front of the temple to denote purity, reflects its elegant architecture. Beyond the pond, the temple seems to rise up from the ripples of the water into another and more beautiful universe.

Jocho (d. 1057), the most famous sculptor of the age, was commissioned to create a large image of Amida Buddha to sit in the main hall. What exactly was his aspiration as an artist in this case? The strength of the *Shaka Triad* (see figure 13) was no longer appropriate, nor was the fierce power of Fudo (see figure 18). Instead, Jocho had to create an image of Amida as a compassionate deity who would listen to the prayer of even the humblest sinner.

Until this time, wooden sculpture had been created by the "single-block" method, in which all but a few appendages were carved from a single log of wood. Jocho perfected the "multiple-

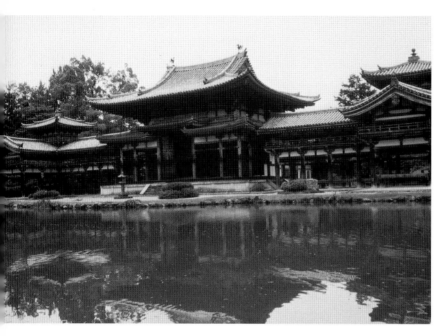

20. Byodo-in. Dedicated 1053. Uji

Opposite:
21. Jocho (d. 1057). *Amida Buddha*. 1053. Cypress wood with lacquered cloth and gold leaf, height 9'2" (279.4 cm). Byodo-in, Uji

block" or "joined-wood" technique, in which each section could be carved from a different piece of wood, then joined together. This required more complex planning, but it also allowed more freedom for the sculptor. In his great *Amida Buddha* (figure 21), Jocho created an image that is simultaneously massive and compassionate, awesome and approachable, unworldly and humane. The gold covering the wood reflects light, giving an effect of radiance, even from across the pond, yet the gentle expression on the Buddha's face reassures the believer that Amida is a deity who will understand human imperfections, and will reward those who chant praise to his name with rebirth in the Western Paradise.

Nowadays, we no longer have to make the long pilgrimage by foot or horseback to visit the Byodo-in; a train from Kyoto takes us to a ten-minute walk from the temple. Yet as we come into view of the Phoenix Hall, we can still feel some of the wonder that must have been so powerful to believers in Pure Land Buddhism during the eleventh century.

But there are two surprises. First, instead of being a static work of art, the Byodo-in keeps changing. Architecture depends on light, and Amida is the Buddha of light. The illumination of the Byodo-in in its mountain clearing varies from the cool gray of dawn through stark noontime brightness to the warmth of the setting sun. Wind ripples the hall's reflection in the pond; rain grounds the temple in wet earth. In winter, the columns gleam red against the white snow; in summer, the entire Phoenix Hall can seem to shimmer in the waves of heat. Jocho's gilded *Amida Buddha,* responding to the daylight, also changes from bright to muted, from dazzling to softly glowing. Even in a single moment, if clouds pass over the sun, the temple and its magnificent main sculpture can change mood and expression, giving a sense of life.

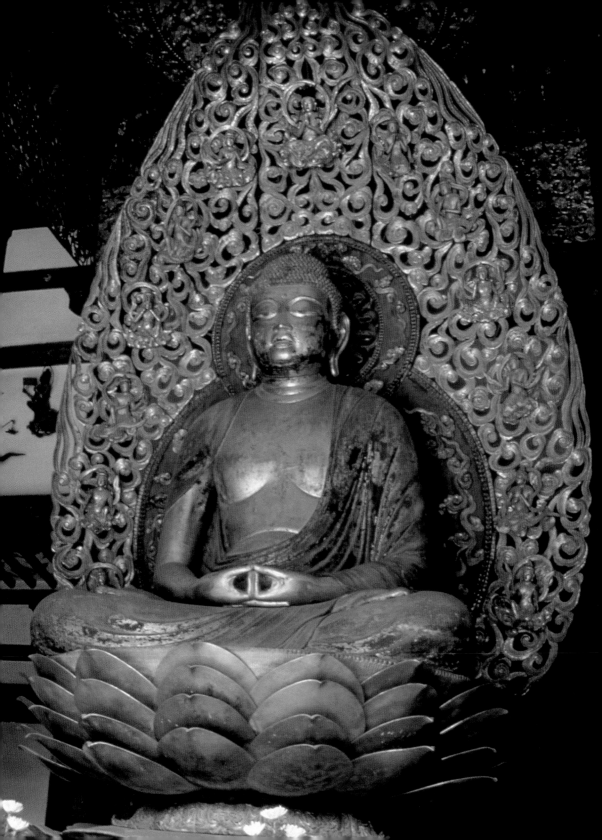

The second surprise is that despite the grandeur of the site and the beauty of the temple, the hall containing Jocho's *Amida Buddha* is unusually small. Why should this be? Consider the difference between entering a large temple, church, or cathedral and entering a much smaller space dedicated to religious use. What does each experience suggest about the viewer's relationship with the divine? Other forms of Buddhism intend the larger scale of great temples to awe the viewer with the power and grandeur of the religion. But in Pure Land Buddhism, it is the individual's relationship to the deity that is most important, and therefore the Byodo-in was intended to convey the personal experience of entering paradise after a long spiritual and physical pilgrimage.

Later Buddhist Sculpture

During the Kamakura period (1185–1392), in a society now dominated by warriors rather than courtiers, new trends in sculpture became prominent. The most significant of these was a strong interest in realism. Portraits of monks became even more lifelike than the sculpture of Ganjin (see figure 16) and were sculpted with great care for naturalistic detail. But it is difficult to make a deity seem realistic while still remaining godlike. Master sculptors devoted themselves to creating fully volumetric forms, convincingly modeled robes and drapery, and effective poses and gestures, without sacrificing religious intensity in their art. The use of inlaid crystal eyes also added to the feeling of realism in many Kamakura-period sculptures.

In the succeeding Muromachi period (1392–1568), Zen Buddhism became the dominant religious and cultural force. Based on disciplined meditation leading toward enlightenment, Zen inspired painting, calligraphy, and gardens,

but it did not emphasize traditional sculpture. Many experts believe that the great age of Japanese sculpture ended in 1392, but some marvelous images were created after that time, and they should not be ignored.

Although Zen was culturally dominant in the medieval era, Shingon, Tendai, and Pure Land Buddhism continued to have large numbers of believers, and many impressive traditional images were carved for their temples and personal altars. In later centuries, Buddhist beliefs have led to more individualized images created not only by major artists, but also by ordinary people.

Ito Jakuchu (1716–1800), one of the great painters of the eighteenth century, was a devout Buddhist, even becoming a monk late in his life. He donated many of his paintings to temples, but in his old age he decided to do something more to express his religious spirit. He therefore designed a large number of stone sculptures to sit in a bamboo grove on the hill above the temple of Sekiho-ji, at the edge of the mountains southeast of Kyoto. Unlike most earlier Buddhist art, these sculptures are rough, seemingly crude, and decidedly inelegant. Why would Jakuchu create such strange images?

Jakuchu's fundamental Buddhist orientation was to Zen, which fosters the direct experience of everyday reality. There is no need for complex esoteric images or radiantly beautiful Buddhas. Instead, Zen-inspired painting and calligraphy, and more rarely sculpture, usually have a rough and dramatic impact that expresses the power of the enlightenment experience.

Visiting Sekiho-ji is very different from visiting Horyu-ji, To-ji, or Byodo-in, and many fewer people make the effort. Those who do climb up the mountainside behind the small temple will encounter Jakuchu's strange stone figures, some partly covered with moss, already beginning to

erode and crumble (figure 22). Even more than images in temples, these works change their appearance within the changing light of their environment: stolid in the cool clarity of early morning, glaring in the midday sun, and almost obscured in the late afternoon shade.

The sculptures on the hillside represent Shaka teaching his disciples; the death of Shaka, attended by lamenting human followers and even a few grieving animals; and Amida with attendant Bodhisattvas. Most common, however, are groups of *rakan,* enlightened followers of the Buddha who care nothing for worldly matters. *Rakan* are often represented as strange or ugly old men, whose faces show the evidence of their struggle to attain enlightenment. Surrounded by giant trees, set among twisting bamboo roots, and sometimes partly covered with leaves, many of the sculptures glower and grimace like gnomes or elves. They may seem more malignant than friendly, but their vital presence is inescapable.

A single photograph can hardly represent the fascinating sculptures at Sekiho-ji. One of the many gruff figures, however, will have to represent them all. He is probably a *rakan,* and he has been carved quite simply, a mournful little creature with downturned eyebrows and a grimly set mouth. His body is only suggested, and the stone retains much of its natural shape. This should not surprise us, since the respect for natural materials is shown in every facet of Japanese art. That a touch of humor can appear in a Buddhist image may seem more unusual, but the immediacy of humor is a vital component of Zen Buddhism, where it helps break down the illusions that arise from habitual ways of thinking.

People react differently to this little gnome-*rakan.* To some, he expresses the dread of a ghostly creature emerging from the earth, while to others he has the direct appeal of a child's

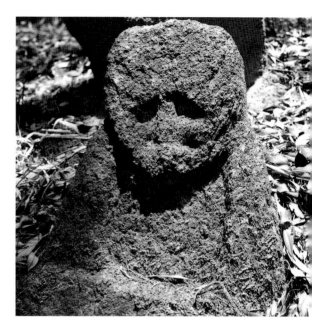

22. Ito Jakuchu (1716–1800). *Rakan.* Stone, height 13⅛″ (34 cm). Sekiho-ji, Fushimi, Kyoto

teddy bear. Some viewers see both aspects at once, and this combination may bring a rueful smile at the uniting of opposites.

If Jakuchu's sculptures seem strange, they are nonetheless part of a long tradition of stone images in Japan. Often standing along country paths or outside obscure temples, "Stone Buddhas" attest to the deep-rooted beliefs of the Japanese people. Although carved crudely, these sculptures convey a sense of natural strength and dignity that can sometimes put to shame their more elegant cousins in major temples in the cities.

In 1976, a young monk was given charge of a rather dilapidated temple called Otagi Nembutsu-ji on the western outskirts of Kyoto. He was told that since there were no funds for temple renovation, he should attempt to raise

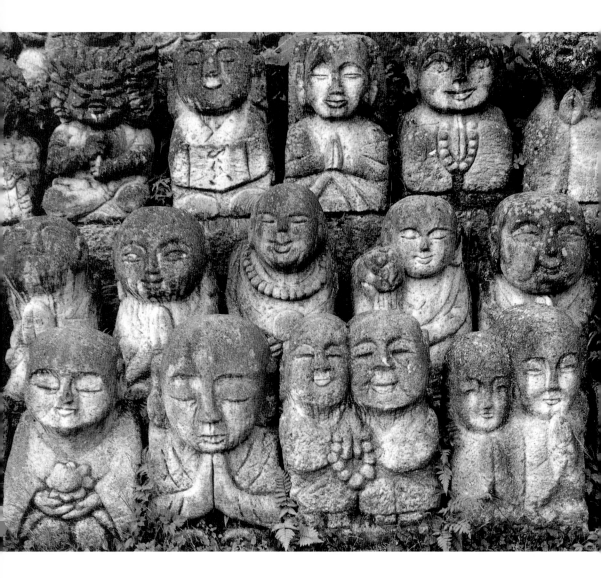

23. *Modern Rakan.* c. 1981. Stone,
height of each approx. 26″
(66 cm). Otagi Nembutsu-ji,
Kyoto

money on his own. Not knowing any wealthy
people, he wondered what to do, but soon con-
ceived a unique plan. Since he had some skill in
stone carving, he conceived a project of inviting
the public to come and create a set of five hun-
dred images of *rakan*. Each volunteer, for a mod-
erate fee, was first given a rectangular block of
stone, tools, and a few lessons, and then set loose
to create a Buddhist sculpture.

The results were remarkable. Modern Japanese responded with varied, imaginative, and often delightful images. The project was such a success that it has been repeated several times, and may be tried once more if room can be found on the temple grounds for yet more sculptures. Meanwhile, the monk has raised enough money to repair the temple buildings and build a small tower with sonorous bells that any visitor may ring.

There are now 1,200 stone images gathered in large groups on the hill overlooking Otagi Nembutsu-ji. These stone *rakan* have been boldly carved by everyone from butchers to secretaries and from shop owners to students. One series of sculptures shows a typical range of images (figure 23). Several are praying, a few are smiling, and one couple in the front share their Buddhist prayer beads with a marvelously joyful intimacy. Lined up on terraces, the *rakan* seem unconcerned with the ravages of weather and time. In fact, they may be growing more beautiful with age, as rain washes their darkening heads while lichen give them a sense of texture. As with the earliest Japanese Buddhist sculptures (see figure 13), the heads and hands are large, the bodies less important. There may seem to be a consistency of style in this group, but on close examination, it can be seen that each face and pose is different from the others, and the expressions range from sincere to somber, from serene to self-satisfied.

In other sections of the temple grounds there are *rakan* holding sports equipment, cameras, and musical instruments, and even one fellow standing on his hands with an upside-down smile. But the overwhelming majority are less spectacular, showing instead a feeling of belief and inner confidence that is quite moving to visitors. They also demonstrate that Japanese sculpture is still a living art.

Key Questions When Looking at Sculpture

Subject. What subject does this sculpture represent? What was its purpose and function? What kind of belief does it embody, and how does it express this belief?

Context. Is this work now in its original setting? If not, how might it have been shown originally? Would it have been seen from above, from below, or from the same level? Was it part of a larger group? Would it have been in a temple? If so, how might it have looked there?

Form. Does this sculpture have a strong frontal presentation? How does it look from different sides? From different angles? In different lights? Is it self-contained or gesturing outward? How has the material (wood, bronze, clay, lacquer, and so on) been used?

Style. Is this work primarily rounded or angular? Detailed or simplified? Smooth or rough? Linear or volumetric? Individualized or abstracted? How is the style related to the original function of the image?

3. SECULAR AND ZEN PAINTING

24. *The Tale of Genji* (section).
Early 12th century. Color on
paper, height 8¼″ (21 cm). The
Tokugawa Art Museum, Nagoya

*U*ntil the modern era, Japanese paintings
were executed by applying ink and water-
soluble colors with animal-hair brushes to paper
or silk. These materials greatly influenced the re-
sults. For example, there was no way to correct
or repaint an unsatisfactory area; unlike oil paint
on canvas, a line or color on paper or silk could
not be effaced or changed. Therefore, artists had
to envision the entire painting in their minds be-
fore they could start, rather than working toward
an artistic destination that was still evolving.
Once a single stroke of the brush was made,
every other brushstroke had to be balanced with
it until the painting was finished.

The inability to correct made painting more
difficult, but it also had advantages. Since great
facility with the brush was required, Japanese
paintings tend to be fresh and lively, and often
have a feeling of spontaneity. Also, artists had to
work with intensity, knowing that a single weak
or irrelevant stroke of the brush could ruin a
painting. This was true both for fully detailed,
colorful works, and for more subtle ink paint-
ings. In this chapter, we will examine five of the
most important forms of painting in Japan: nar-
rative handscrolls, ink landscapes, paintings by
Zen Masters, decorative screens, and literati fans
and scrolls.

Narrative Handscrolls

Court life in the Heian period (794–1185) was
extraordinarily sophisticated, full of ceremonial
rituals and highly developed in many arts. In ad-

dition, court ladies and noblemen who sought a life of pleasure were often involved in love affairs. Personal beauty in a lover was admired, but not as much as skill in poetry, painting, calligraphy, fashionable dress, music, and aesthetic games such as incense identification.

The Tale of Genji, the world's first novel, was written in the early eleventh century by Lady Murasaki, a noblewoman at the Imperial court. Because it so fully captures the spirit of aristocratic life, *The Tale of Genji* has been copied and illustrated many thousands of times over the centuries. The earliest surviving *Genji* paintings, however, have a special place in Japanese artistic history because they were created in the early twelfth century, while courtly ideals still held sway; the exquisite refinement of the later part of the Heian period has never been equaled.

The first paintings of *The Tale of Genji* were originally interspersed with elaborately decorated calligraphic sections of the novel in handscrolls that could be unrolled at the viewer's own pace, telling the story though words and images. But the text did not just explain the pictures, and the pictures did not merely illustrate the text. Rather, each added a distinct level of meaning to those viewers familiar with the conventions of society during an elegant era in Japanese life.

Genji himself is described by Lady Murasaki as a "shining prince," handsome and talented in every art. Over the course of the novel, he has several affairs with court ladies, but his wife, Princess Nyosan, also has an affair that leads to the birth of an illegitimate son. Genji and his wife still love each other, but neither can admit to the other, or to anyone else, that the child is not their own.

One of the surviving *Genji* paintings depicts the scene in which Princess Nyosan's father, the retired Emperor Suzaku, visits to try to persuade his disconsolate daughter not to withdraw from

court life to become a Buddhist nun (figure 24). The three main figures are placed on the left side of the painting, rather than at the center. The ex-Emperor, who has shaved his head as a lay monk, tries to hide his tears with his hand; Princess Nyosan covers her face with her sleeve; and Genji sits near the bottom of the painting in a mournful posture. The emotional isolation of each figure is emphasized by the screens that divide the composition into a series of complex diagonals, so that the ladies-in-waiting on the right are also caught in the unhappy drama of the scene. Typical of Japanese narrative painting is the lack of a roof, so we can see into the private world of human emotions, becoming voyeurs at this complex scene so fraught with unspoken sorrow.

Why has the artist chosen this moment to portray? Lady Murasaki's novel is about the splendors of court life, but underlying the

25. *The Frolicking Animals* (section). Late 12th century. Ink on paper, height 12½″ (31.8 cm). Kozan-ji, Kyoto

courtly pursuit of art and pleasure is the Buddhist truth of impermanence and the inevitable sorrows of life, even for those at the pinnacle of society.

The Tale of Genji remains one of the great artistic monuments of Japan. The expression of high culture, the evocation of a fully aesthetic way of life, and the irony of the human search for happiness are all richly expressed in the novel and the paintings based on it. The muted colors, the understated brushwork, and the dramatically split compositions of the handscroll express the underlying emotional turmoil with great and subtle beauty.

The artistic focus that the finest painting demands can be seen in several other and very different Japanese narrative scrolls. One of the masterpieces of Japanese ink painting is *The Frolicking Animals,* a handscroll from the late twelfth century without text. Depicting animals such as frogs, monkeys, rabbits, and foxes making fun of human behavior, it was supposedly painted by an abbot of a Buddhist temple named Toba Sojo.

What was the historical context of such a scroll? During the twelfth century, control of the government by courtiers was coming to an end, and the age of the warriors was about to begin. Samurai believed that their strength and valor were more important than the ability to write poetry or to show exquisite taste in garments. While courtiers considered the warriors uncouth, samurai believed that the nobles were effete. It was in this cultural context that *The Frolicking Animals* was created. Let's examine one section where a frog has just won a wrestling contest with a rabbit, and boasts proudly of his triumph (figure 25).

The brushwork is almost entirely outline; there are just enough internal strokes to suggest

the fur of the rabbit and the skin of the frogs. There is no color, so the entire effect is produced by line. Everything is immediately clear, with no extra strokes of the brush. By setting the action against the blank white of the paper with minimal background, the artist effectively sets off the liveliness of the animals: the rabbit is upended, the frog leans back in victory, and the spectators laugh uproariously.

Why is the painting so remarkably lively? First, the lines are all curved, with no straight or angular brushstrokes to be seen. Second, the lines are not even in width, but swell and taper to suggest the bodies and actions of the rabbit and frogs. Third, the lines echo and balance each other to create a sense of unity as well as dramatic contrast.

Examining the brushstrokes more closely, the single strongest line is found on the back of the defeated rabbit. This semicircle is repeated in the back of the victorious frog and the bellies of two spectator frogs on the left. These curved lines are balanced by opposing curved lines that appear on the belly of the right frog, the right leg and head of the rabbit, and the backs of the frogs on the left. By repeating these strokes of the brush, the artist has unified the composition rhythmically.

In terms of form and composition, there is also a sense of unity within the dramatic activity. The victorious frog is portrayed in a diagonal pose, rising toward the right. The rabbit is set in a similar diagonal, so the space between them becomes a third diagonal form. This creation of "negative space" is vital in Japanese painting, and here it is masterfully handled. The artist then achieved contrast by opposing diagonals, such as the arms of the rabbit and the tallest frog on the left, and the legs of the spectator frogs. The legs of the frog on the right, however, serve a different purpose. The right leg is bent to hold the

frog's weight—his entire body firmly depends on this leg for balance.

Seen as a whole, the composition is built around the rabbit at the center, who is encased as if in a pair of parentheses by the single frog on the right and three frogs on the left. The rabbit, although defeated, is thus the focus of the composition, and has been given the most dynamic brushwork.

Like the *Tale of Genji* scrolls, *The Frolicking Animals* has been designated a National Treasure in Japan. Is this surprising? Some people might argue that it is little more than a lively cartoon, but study of the brushwork and composition confirms the skill of the artist. Unlike the victorious frog, he does not show off his performance, but remains content with the small format and modest means of brush and ink. This handscroll is so unassuming that it is easy to overlook how it demonstrates many of the special features of Japanese art: a respect for the basic materials of brush, ink, and paper; an asymmetrical balance in its composition; a sense of playfulness and humor; and a delight in fantasy.

Ink Landscapes

The great skill in the use of brush and ink by Japanese painters became even more evident in Japan's medieval period, when both the control of samurai and the influence of Zen became especially strong. The most famous painter in Japanese history, Sesshu Toyo (1420–1506), entered a monastery at the age of eleven and was ordained a Zen priest a few years later. However, the cultural influence of Zen in the fifteenth century was so pervasive that many major temples established painting studios, and some monks like Sesshu became specialized as artists. They produced decorative screens, sliding-door paintings, and scrolls, intended for temples, palaces,

26. Sesshu Toyo (1420–1506). *Winter Landscape*. c. 1470s. Ink on paper, 18¼ × 11½″ (46.4 × 29.2 cm). Tokyo National Museum

Below:
27. Compositional diagram of Sesshu's *Winter Landscape* (figure 26)

and the mansions of the rich, and even for trade with China.

Winter Landscape (figure 26) is one of Sesshu's most celebrated works, demonstrating within its relatively small size his great power of the brush. Although the ink-landscape-painting tradition in Japan had been more soft and subtle before his time, Sesshu, who lived at the start of a long period of incessant civil wars, changed its focus to strength and dramatic contrast. A cliff appears from nowhere, dividing the composition in half near the top and beginning the series of strong compositional accents that dominate the painting. The landscape is primarily constructed of strong, alternating diagonals. The first of them consists of the lower rocks and path leading up to the left; next comes the middle-ground rocky mass angling up to the right; then the bend of the cliff, moving up to the left again; and finally the outline of snowy mountains cutting up to the right (figure 27). Each diagonal is at a sharper angle, and since the use of diagonals generally gives paintings a sense of strength and movement, Sesshu's composition is exceptionally powerful.

The brushwork complements the composition. Lines are strong, straight or angular, and almost never curve. Internal lines ("texture strokes") within the rocks and mountains echo the strong outlines with sharp accents, and the trees struggling to survive the winter desolation are also created with heavy, angular outlines and crisp dashes for their bare branches and twigs. A tiny human figure appears in a small space cell created by a recession in the foreground rocks; he has come from an almost hidden boat at the lower right and walks toward a temple in the deep middle ground. This temple is the only pictorial relief from the almost oppressive power of nature, but it too is composed of strong diagonal lines. Everything is contained; there is no real

28. Sesshu Toyo (1420–1506). *Broken-Ink Landscape*. 1495. Ink on paper, 58⅞ × 13" (148.9 × 33 cm). Tokyo National Museum

sense of deep distance, despite the overlapping forms, nor an unobstructed view of horizon or sky. Sesshu evokes the chill of winter less in the specifics of frost and snow than in the cutting angles of his composition and brushwork.

If Sesshu's *Winter Landscape* is the epitome of sharply angular brushwork, then his *Broken-Ink Landscape* (figure 28) is the opposite, full of soft tonal effects and revealing few precise brushstrokes. This contrast reflects the Japanese toleration of (or perhaps love for) opposites, and also shows the technical range that was available to the medieval artist.

The "broken-ink" style originated in China, where it had been practiced by Mu-ch'i (1177–1239), a Zen Master whose works were avidly collected in Japan. The primarily soft and wet ink play of this style is redolent of summer scenery, and thus one contrast between the two Sesshu paintings is seasonal: winter versus summer. Another contrast is between a composition based on strong diagonals and one in which vertical and horizontal elements dominate. Finally, there is a contrast between clear, angular lines and informal, seemingly imprecise brushwork; this has been compared to the differences in calligraphy between standard (printed) script and fully cursive (free) writing.

At first this landscape may seem incoherent. The more we look, however, the more we can see how this painting is not indefinite smears at all, but actually highly controlled artistry in which the skill was deliberately hidden from the first glances of the viewers.

How did Sesshu paint this landscape? One can almost imagine it was a kind of game, in which he spread gray ink freely and then set himself the puzzle of making sense of the result. Certainly the semi-abstract gray areas came first, partly enlivened with darker ink, and only at the end did a few precise strokes of the brush depict the huts and boat. It is these precise strokes, however, along with the shapes of the distant mountains, that give this painting a sense of scale, without which it would be impossible to understand as a landscape. With the hints that the artist has given us, we can gradually imagine the center section as a large tree, with another tree to the left, rocks below, and sky, mist, and water on all sides.

This kind of painting requires the viewer's close participation. Instead of strong outlines and naturalistic details, *Broken-Ink Landscape* suggests more than it defines, and perhaps it is more a picture of light itself than of the mountains and tree—light evoked by empty paper, by space, and by the imprecise forms that the brightness surrounds and infiltrates. A picture of light on water, light through mist, light from the sky—what the painter has not painted is more evocative than what he has, and what is empty is more significant than what is full.

This is an interesting painting to copy. Given ink, a brush, and paper, anyone can try, and perhaps this would be the best way to understand what Sesshu has done. First apply thick gray areas, then black accents, then a few specific strokes to suggest a human presence and to give scale to the forms—that is all. If you try it, it can be a fascinating experience. But you will soon realize that while many other artists in Japanese history have also done "broken-ink" landscapes, each is different; many are effective, but none is quite like this one.

We have seen two very different ink paintings by the same master. Both start with a vertical thrust in the upper center, but from there they diverge: sharp and misty, harsh and soft, chilly and warm, defined and suggestive, full and empty—winter and summer. Yet in strange ways they may evoke each other as opposites that finally become one.

Paintings by Zen Masters

The civil wars that devastated Japan in the fifteenth and sixteenth centuries eventually led to a new era, begun when three successive Shoguns reunited Japan at the end of the sixteenth century. The succeeding Edo period (1600–1868) was to last until Japan was forcibly opened to the West by Admiral Perry's warships and modern Japan was born.

The Edo period marked the end of official sponsorship of Zen as a cultural force. Like most changes, this had both favorable and less favorable aspects. On the one hand, Japan became a great deal more secular, with the growth of a strong mercantile economy and its inevitable stress on money and position. On the other hand, after some difficulties Zen gained inner strength by being separated from government sponsorship, and those who chose the demanding road of Zen training were able to offer society an alternative to worldly values. Zen art shows the change clearly, from the powerful and poetic landscapes by artists such as Sesshu to the simple and profound paintings by the great Zen Masters of the Edo period.

Before introducing a specific artist, we might first look at a painting (figure 29) of the most basic subject for Zen Masters, the first patriarch, Daruma (Bodhidharma in Chinese). Coming from India to China in the sixth century, Daruma is said to have meditated continuously for nine years in front of a wall before accepting his first pupil and thus beginning the transmission of East Asian Zen. It is the fierce concentration of Zen meditation that is expressed in all Daruma paintings.

It may alter your perception of the work to know about the artist's life. Fugai Ekun (1568–1654) represents the change from painters who were also monks to monks who also painted. Thus, we might call Sesshu a painter-monk, and Fugai a monk-painter. The change meant that art now became a form of visual introduction to the inner world of Zen, and also an individual expression of enlightenment. Fugai was a true hermit-monk; at the age of fifty he gave up his position as abbot of a temple in order to live in a mountain cave. He owned only a single bowl, so he once served one of his rare guests a meal of rice gruel in an old dried skull. The guest, although an esteemed monk himself, was horrified and fled. Fugai spent his last years wandering, and when he was ready to die, he reportedly paid some workers a few coins to dig him a hole, then stood upright in it and passed away. Do these episodes in his life lead you to see his work differently?

To admirers of Zen painting, Fugai's art has a special expressive quality. The gray lines, not beautiful but descriptive, the asymmetrical position of the figure on the paper, the tones of ink, the use of a few black strokes for the mouth, nostrils, ears, and especially the dots of the eyes—these reach the heart directly and without artifice. This painting brings to mind the words attributed to Daruma, which sum up the fundamental message of Zen:

> Point directly to the human heart,
> See your own nature and become Buddha.

Fugai exemplifies the values of a hermit-monk, but Zen also can have the aspect of reaching out to a wider public. The greatest Zen teacher of the past five hundred years was Hakuin Ekaku (1685–1769), who created a great deal of calligraphy, painting, poetry, and prose as a means of reaching people at all levels of society. Hakuin lived most of his life as the Zen Master of a small country temple. Such was the depth of

29. Fugai Ekun (1568–1654). *Daruma*. Ink on paper, 13 × 7⅞" (33 × 18.7 cm). Private collection

his understanding and the power of his teaching that he attracted Zen pupils from all over Japan, and the Hakuin tradition continues to influence Zen training in Japan.

Hakuin's autobiographical writings describe his own training (which was very severe), his intense meditation, his deep doubt ("like being frozen in a great sheet of ice"), and his first enlightenment ("as though the sheet of ice had been smashed"). Despite his many sermons and extensive writings, however, Hakuin in his final decades went beyond words in his expression of Zen. He turned to brushwork in his late fifties and sixties, and before his death twenty-five years later he had created several thousand works of Zen painting and calligraphy. These he gave to his followers, both monks and lay pupils, and they have been treasured ever since as direct transmissions of Hakuin's Zen spirit.

Most Zen paintings before the time of Hakuin had depicted a limited number of traditional subjects such as landscapes or portrayals of Daruma and other Zen Masters of the past. Hakuin revolutionized Zen painting, creating an entirely new visual world of Zen. He used every kind of subject, including folk themes, birds, animals, gods, devils, and scenes and objects from everyday life. One of his unique themes is *Blind Men Crossing a Bridge* (figure 30).

According to one story, Hakuin had noticed that near his country temple there was a deep gorge spanned only by a dangerous log bridge. He envisioned this bridge as a metaphor for human life, with each of us striving to reach the opposite shore of enlightenment. But blinded by our own desires and illusions, we find it difficult to cross the bridge. Hakuin therefore painted the scene and added the following poem:

> Both our inner life and the floating world around us

30. Hakuin Ekaku (1685–1769).
Blind Men Crossing a Bridge. Ink
on paper, 7⅝ × 26½″ (19.4 ×
67.3 cm). Private collection

Are like the round log bridge of the blind men—
A mind that can cross over is the best guide.

Hakuin made a pun on the original Japanese
word for "guide," suggesting that we are "hang-
ing on by our fingernails."

The painting is deceptively simple. Three
figures, each less than an inch high, are crossing
a bridge, with suggestions of mountains in the
background. By just a few dashes and dots of
gray ink, Hakuin clearly delineated each of the
three postures. The blind man at the right takes
off his sandals so that he can gain purchase by
feeling the log bridge with his feet. The one in
the middle is now crawling forward, his staff in
his belt. The man at the left uses his staff for bal-
ance, with his sandals hanging at the end. When
they finally approach the opposite side, they are
still in danger, because the bridge does not ex-
tend all the way across.

By showing an everyday scene that people
can instantly understand, Hakuin has gone be-
yond traditional themes to a more direct form of
Zen expression. The modest subject and style
only increase the pungency of the painting; it
has, as a Japanese might say, "the aroma of Zen."

All books on the history of Japanese Zen will
feature the teachings of Hakuin, and we may find
it surprising that the greatest Zen Masters in
Japan were also the greatest Zen artists. After all,
we don't have paintings by popes or theologians
in the West. But since brushwork was learned by
all educated Japanese, painting could be a nat-
ural outgrowth of calligraphy and poetry. In ad-
dition, Zen stresses active involvement in all
activities; Zen monks grow their own food and
maintain their own temple grounds; they also do
their own painting.

Perhaps the most beloved of all later Japan-
ese Zen painters was the monk Sengai Gibon
(1750–1837). In his final years, like Hakuin, he
turned to brushwork as a form of Zen expres-
sion. He was soon so besieged by requests for his
paintings that at one point he ironically com-
plained that people mistook his simple hut for

an outhouse: they were constantly bringing paper.

Many of Sengai's works show the humor that is so much a part of Zen, but one of his most famous paintings is *Circle, Triangle, and Square* (figure 31). This scroll has fascinated people ever since it was created. Rather than a single level of black or gray, the ink tones keep changing. The forms overlap just a bit, suggesting some interconnections between these very fundamental shapes, but ultimately we are left with the geometric forms, created with free brushwork. Why did Sengai paint this picture? What does it *mean*? Here we come to a difficult conundrum, like a mysterious meditation question (or *koan*) that a Zen Master might give a pupil to meditate on.

Zen Masters often paint just the circle, and from their inscriptions we know that it can mean the universe, the void, the moon, or even a rice cake (Sengai once wrote, "Eat this and have a cup of tea!"). But there is no inscription on *Circle, Triangle, and Square*, merely Sengai's elaborate

31. Sengai Gibon (1750–1837). *Circle, Triangle, and Square*. Ink on paper, 11⅛ × 19″ (28.3 × 48.3 cm). Idemitsu Museum of Arts, Tokyo

signature. So what does the painting mean? Commentators have suggested a number of interpretations: the basic forms of the mandala and the pagoda; the earth, humanity, and heaven; the Buddha, Buddhist laws, and the Buddhist community; three forms of Buddhism; three schools of Zen; and more.

Elaborate explanations are of little help in this case. The actual experience of Sengai's art is what counts, and commentaries are useful only when they take us toward the painting, not away into abstract concepts. In Zen, as in art, words are secondary; seeing is primary. Perhaps Sengai's painting means just what it is: a circle, a triangle, and a square.

Decorative Screens

In great contrast to the simplicity and rough vigor of Zen brushwork is the Japanese decorative painting tradition, seen at its most sumptuous in golden screens. One leading master of this tradition was Tawaraya Sotatsu (d. 1643?), about whom not much is known. His family made fans and paintings to be placed on screens, and he himself worked closely with other artists and artisans to create some of the most splendid works of the seventeenth century.

Sotatsu repaired ancient handscrolls, in the process learning much about the earliest tradition of Japanese painting in color, and he also

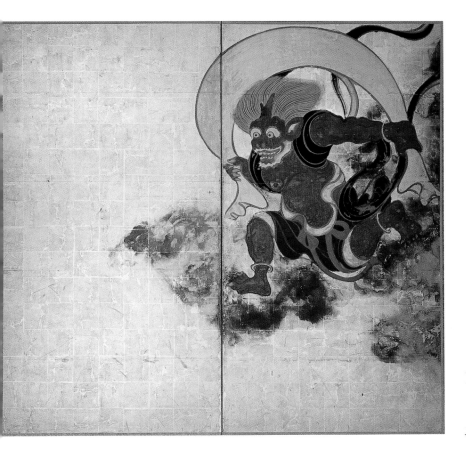

32. Tawaraya Sotatsu (d. 1643?). *Wind and Thunder Gods*. After 1621. Color and gold and silver paint on paper, each 59 × 64¾″ (149.9 × 164.5 cm). Kennin-ji, Kyoto

mastered the technique of subtle ink paintings. However, his greatest skill came in choosing what might earlier have been details or partial sections of paintings, enlarging them, and emblazoning them boldly on scrolls and screens to create dramatic and decorative works of a kind never seen before.

Although pairs of screens were usually crafted with six folds each, one arresting pair of two-panel screens by Sotatsu portrays the *Wind and Thunder Gods* (figure 32). Set against brilliant gold leaf, these deities of nature are painted with exceptionally strong forms, lines, and colors. The concept of one god with a bag of wind and another with thunderous drums was adopted from Southeast Asia, where tuned circles of drums can still be seen in Burmese traditional orchestras. Earlier paintings and sculptures show these deities as fierce, but here, despite their dramatic size, they seem more humorous than frightening; the Japanese sense of play is very apparent in these screens. The wind god strides eagerly into the right-hand screen on a cloud of ink, brandishing his bag. His partner, the thunder god, seems full of enjoyment as he strikes his little drums with a barbell and cow horns.

How did Sotatsu create such powerfully expressive images? Unlike more subtle ink paintings, *Wind and Thunder Gods* may seem to reveal its entire artistic content at a single glance. How-

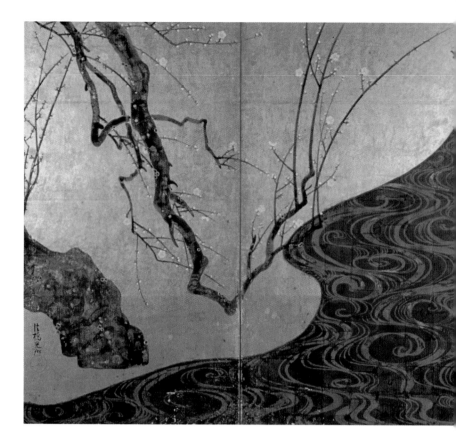

ever, a close study of the screens reveals more aspects of Sotatsu's mastery. First, he limited himself to a few strong colors against the shining gold leaf. The wind god has a green body, red sash, white scarves, and golden hair. Somewhat in reverse, the thunder god has a white body, gold and green clothing, and green scarves that occasionally show their white undersurfaces.

Second, the solidly colored bodies contrast with the more insubstantial clouds. These were created with a technique (called *tarashikomi*) of quick applications of ink and water that did not totally mix on the hard surface of the gold, but pooled and merged in interesting irregular tones of black and gray.

Third, the compositions are extremely asymmetrical and full of movement. The left panel of the wind god screen is almost totally empty, with only a small portion of the bag and cloudy ink to relieve the brilliance of the gold leaf. However, the vigorous stride of the wind god seems about to lead him into this empty panel. Even the cloud points like an arrow to the direction he runs toward. Here we have the strength of what is not painted, of what we can imagine; we might call this "imminent action." In contrast, the thunder god on the left is moving more circularly. The clouds, lighter against his white body, help define this circle, as do the drums. Meanwhile, the god's scarf floats all the way to the upper

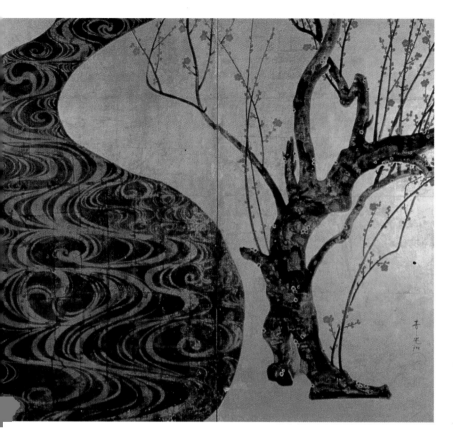

33. Ogata Korin (1658–1716). *Red and White Plum Trees*. Color and gold and silver leaf on paper, each 61⅛ × 67⅞" (156.5 × 172.4 cm). MOA Museum of Art, Atami

right-hand corner of the almost empty right screen. Sotatsu's combination of filled and empty space is always balanced, but never symmetrical.

Finally, the lines of Sotatsu's paintings are confident and full of energy. Seen most clearly in the body of the thunder god, the brushstrokes swell and taper boldly as they define outlines, muscles, and the strangely radiating navel. Everything—arms, legs, hair, even the toes— seems to move. Sotatsu has combined daring composition, brilliant color, and playful humor to create a form of art more dramatically free than anything that had been seen up to his time. He and his successors formed a new decorative school of painting that has continued to influ-

ence Japanese art right up to the present day.

The greatest follower of Sotatsu was not one of his own pupils, but a master who lived almost a century later. This worthy successor to the decorative tradition was Ogata Korin (1658–1716), who practiced several arts but was most celebrated for his paintings. Korin developed his skill in part by copying several of Sotatsu's masterpieces, including *Wind and Thunder Gods*. He then created his own bold designs, and eventually the decorative school of painting was named Rinpa (Rin School) after Korin, who astonished the Japanese artistic world of his day both with his bold and flamboyant works and with his extravagant behavior.

Korin's most famous work is a pair of twofold screens of *Red and White Plum Trees* (figure 33). These embody many fascinating contrasts: trees vs. water, angles vs. curves, pattern vs. naturalism, unity vs. separation, and flat space vs. perspective. As in Sengai's *Circle, Triangle, and Square* (see figure 31), the forms that seem distinct actually touch and overlap each other, and the two screens can be joined to create a single painting or kept separate as individual screens. The trees are full of angles, the water entirely curved, yet they strongly interact, with the right tree seeming to pull back from the water while the left tree bends down toward it.

The use of space in this pair of screens is especially interesting. The trees and water, seeming to extend beyond the confines of the screens, indicate greater space than is actually created by the artist. In terms of perspective, at first everything may seem flat, but actually there are multiple views occurring simultaneously. The trees seem to be viewed from the side, the water from above. The water recedes quickly into the middle-ground distance, suggesting depth, but the overlapping branches of the trees create a sense of shallow space in the foreground. Korin has provided more than simple decoration: his screens invite our attention and confound our easy assumptions.

How does *Red and White Plum Trees* of Korin compare to *Wind and Thunder Gods* of Sotatsu? There are many similarities. First, if we imagine the Korin screens without the water, we can see that the trees have much in common with the deities of Sotatsu. On the right screens they both feature a strong color (red or green), while on the left they stress white against the gold. Second, Sotatsu and Korin both use merging ink, or ink and color, to provide contrasts with the strong, solid colors. Third, in terms of movement, the right tree and the right god spring forth; the left

ones move more in circles. Finally, the right-hand branch of the white cherry tree, like the scarf of the thunder god, reaches all the way to the upper right corner of the left screen.

Yet, with all these similarities, the works by the two artists are still very different. Sotatsu's screens are more bold and direct, while Korin's are more sophisticated. Sotatsu leaves a great deal of empty space; Korin tends to fill his compositions. Sotatsu's art is spatially more simple, Korin's more complex in terms of multiple perspectives. In most areas of art, followers tend to elaborate on the style of the pioneer masters, gaining in detail and variety while sometimes losing in strength. In the case of Sotatsu and Korin, we can see both great masters producing screens of astonishing decorative beauty.

Literati Brushwork

Seemingly in complete opposition to the decorative paintings of Sotatsu and Korin is the art of Japanese literati, the scholars and poets who painted as expressions of their feelings toward nature. The literati painting tradition had a long and glorious history in China before it came to Japan, but like other foreign traditions it was transformed by the Japanese into something new.

This form of painting is closely allied not only with poetry but also with calligraphy. Japanese scholars, who became familiar with the use of brush and ink in their childhood studies of the Confucian classics and poetry, turned easily to the "brush play" of depicting such subjects as bamboo, plum blossoms, and landscapes. Those scholars who were employed as government administrators or teachers did not need to paint for a living, and could merely enjoy brushwork for its own sake, giving their poems and paintings to like-minded friends. Others who had to earn their living from painting still maintained a free-

34. Ike Taiga (1723–1776). *Lake Tung-t'ing's Autumn Moon*. Ink on mica-covered paper, 10⅛ × 20¾″ (25.7 × 52.7 cm). Formerly Kumita collection

dom of spirit that allowed them to express themselves honestly and directly without excessive concern for public success.

Japanese literati brushwork offers many delights, one of which is the opportunity to learn and experience the personalities of artists from the past. It has long been believed that the flexible Oriental brush cannot lie; it clearly reveals the nature of the painter and calligrapher, the momentary mood as well as the inner character. The painting of the literati is therefore personal, reflecting individual poetic experience with the world of nature.

The individuality of literati art is clearly shown in a fan painting by Ike Taiga (1723–1776). He has chosen one of the "Eight Views of the Hsiao and Hsiang Rivers" of China, a favorite

theme of Japanese painters even though few of them had ever gone to China. In Japan, these eight views became poetic evocations of nature rather than specific portrayals of particular places. Taiga's *Lake Tung-t'ing's Autumn Moon* (figure 34) comes entirely from his imagination.

The means are simplicity itself: ink on fan-shaped mica paper. The curving fan shape is always a challenge for artists due to its configuration. For example, how are the landscape elements such as the ground plane and the horizon depicted? Do they bend to the fan's shape, or stay "realistically" horizontal? Taiga has done both at once, as there is some curving in the waves at the upper left, but less in the lower sections. The result is universal rather than specific, moving rather than static, and personal rather than tradi-

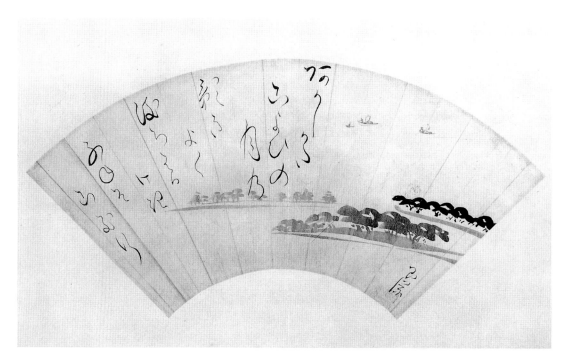

35. Ike Gyokuran (1728–1784).
Akashi Bay. Ink on mica-covered
paper, 6⅞ × 17⅞″ (17.3 ×
44.8 cm). Private collection

tional. Many Chinese and Japanese had already depicted the "Eight Views" by the time this fan was painted in the mid-eighteenth century, but Taiga totally reimagined the scene, producing a completely original interpretation of an age-old subject.

Taiga's motifs also seem deceptively simple: a figure playing a flute in a boat over rippling waves. But let's look more closely. The calligraphy is a vital part of the composition, each character matching the human figure in size. There is no painted moon, but the fourth Chinese-derived character of the inscription, the word for "moon," becomes a moon and reflects over the mica surface in a long diagonal. As the flautist leans away from the calligraphy, his boat disintegrates and becomes water. In return, the vibrating lines of the water include some strokes that hook back, becoming boats. The painting is increasingly gentle as the soft waves spread outward. But is this a painting of moonlight, or a depiction of music? The vibrations of the sound ripple the water, which becomes music, and the music becomes water.

How can we respond to this kind of painting? If we follow the literati spirit, we may respond with our own experience of autumn, of water, of music, and of moonlight, and perhaps with our own painting, prose, or poetry that we might share with a friend:

Mr. Ike Taiga
a Japanese gentleman of the 18th century
paints the autumn night without the moon
but leaves a trail of emptiness
on fan-shaped mica paper
and suddenly there is
more radiance than
any lunar body
could ever
create.

In direct comparison with Taiga's fan paint-ing is *Akashi Bay* (figure 35) by Taiga's wife, Gyokuran (1728–1784). Like her mother and grandmother before her, Gyokuran ran a tea-house in the Gion park of Kyoto. All three were also Japanese-style poets, becoming famous as the "Three Women of Gion." By adding five-line *waka* poems instead of Chinese-style verse to literati painting, Gyokuran became unique in the history of Japanese art. She inscribed this fan painting with one of her most evocative poems:

On Akashi Bay
this evening's moon is
glittering brightly—
boats far out at sea
are rowing away.

With seemingly effortless brushwork, Gyokuran has depicted spits of land and pine trees reaching out into the bay, with boats in the distance. Let's take a few moments to compare the two fan paintings by husband and wife. How are the works alike, and how are they different? Do they convey a similar emotion? If so, by what means? How do they utilize the fan shape? How do they integrate calligraphy and painting?

The marvelous thing about art is that there are no single answers to questions like these; dif-ferent, even opposite, opinions may both be cor-rect. As the theoretical physicist Niels Bohr once said, "A great truth is a statement whose opposite is also a great truth." He was speaking about quantum mechanics, but his words also apply to art and art history.

You may feel, for example, that the two fan paintings are very similar. Both works depict boating at night, both utilize the character for "moon" as part of the visual scene (in Gyokuran's case, beginning the third line of writing from the right), and both emphasize the emotion of loneli-ness by the use of empty space. Are they not similar?

Or you could equally well argue the oppo-site. Taiga emphasizes a human figure, while Gyokuran depicts her boats so far away that the figures can hardly be seen. Taiga avoids trees but portrays the water, Gyokuran the reverse. Taiga bends his composition to fit the shape of the fan, while Gyokuran only slightly tilts the spits of land on the right to correspond with the curved format. Most of all, husband and wife use callig-raphy differently. Taiga writes out a four-word phrase with the bold use of Chinese characters, and keeps the writing within a small and defined block of space. In contrast, Gyokuran writes out a complete poem in Japanese, with more smoothly flowing lines that fill half of the composition.

So are the two fan paintings basically similar, or basically different? The answer must be de-cided anew by each viewer, and will depend on which factors are considered more important. Taiga and Gyokuran shared many artistic joys: he encouraged her painting, she encouraged his po-etry, and they even played musical instruments together. Yet they were also distinct human be-ings, each with a unique artistic vision that we can see in their paintings.

Nakabayashi Chikuto (1776–1853) had a very different personality, and his paintings are

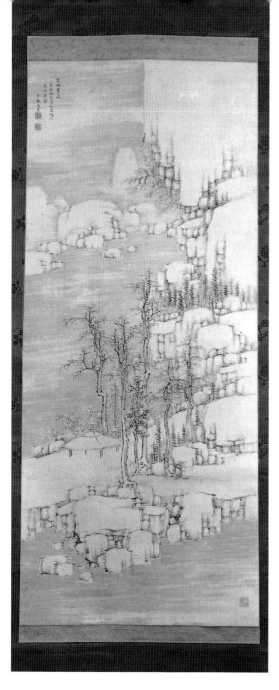

therefore not at all like those of either Taiga or Gyokuran. Chikuto believed that artists should learn from the great traditions of China, and not hurry to establish an individual style. Instead, in due course the inner nature of the painter could not help but shine through every example of his or her brushwork. Chikuto's own ambition was nothing less than to learn, and eventually to transform, the greatest literati styles of China.

Chikuto's *Winter Landscape* of 1833 (figure 36) makes an interesting comparison not only to the Taiga and Gyokuran fan paintings, but it shows even a more notable contrast to Sesshu's *Winter Landscape* (see figure 26), painted three and a half centuries earlier. Both Chikuto and Sesshu began with a Chinese tradition and personalized it. Which painter conveys the feeling of winter more effectively? Or, better, how does each artist experience and visualize winter?

Sesshu is extremely dramatic, with strong diagonals, overtly powerful lines, and an enclosed, almost claustrophobic composition. In comparison, at first Chikuto seems very tame. His composition is based more on stable verticals and horizonatals than dynamic diagonals, and his brushwork is more refined, with individual lines almost unnoticed from a distance. Yet there are more points in common than we may at first think. Like Sesshu, Chikuto begins with a vertical cliff splitting the upper section of his painting, and in his own way he creates a sparse, chilly mood. But just how does he do it?

The artist himself provides a clue. In his inscription Chikuto writes not only the date equivalent to 1833 and his signature, but also states that the painting is in the style of Ni Tsan (1301–1374), the great Chinese literati master. Ni's landscapes are simple, astringent, and almost empty, and yet they have been greatly admired during later ages for their loftiness of conception and purity of spirit.

36. Nakabayashi Chikuto (1776–1853). *Winter Landscape*. 1833. Ink and white color on paper, 53¼ × 23″ (135.3 × 58.4 cm). Private collection

Like Ni Tsan, Chikuto omits figures from his *Winter Landscape,* painting just an empty pavilion, trees, and rocks. Also like the Chinese master, he uses dry, almost desiccated brushwork with broken lines moving in angular, often rectangular patterns. Chikuto's original contributions include the innumerable cliffs and rocky surfaces composed in complex and not entirely logical spatial overlappings. As we study it, Chikuto's painting, seemingly so quiet and static, begins to vibrate. The sense of movement here is toward and away from the viewer, in and out, rather than moving from side to side through sharp diagonals as in the Sesshu landscape.

In Japanese art, as in the world, nature is seldom still and never lifeless. All four landscape painters subordinate pure visual logic to dramatic or poetic expression: we might say that Sesshu zigzags, Taiga ripples, Gyokuran flows, and Chikuto oscillates. Of the four, Chikuto has the most complex rhythm in his visual dance, and ultimately confounds our normal sense of space the most. Yet his painting is also the most quiet and conservative in brushwork, and perhaps this is exactly the reason: his vibrating space would be lost in more dramatic slashes or wriggles of the brush.

Which of the four paintings we finally admire the most will depend on our own character and experiences. Some people want a painting to suggest a place they would like to visit, ramble through, or live in. From that point of view, which landscape is the most appealing? Others prefer a poetic sense of place that is different, mysterious, perhaps unapproachable. Again, which work best fits that description? Each of these paintings expresses its own individual view of the world, and each can add to our own understanding of art, and of nature, and perhaps even of ourselves.

Key Questions When Looking at Paintings

Materials and Medium. Is the work on paper, silk, or another material? Does it use ink only, or color? Why? Is it a hanging scroll, handscroll, screen, fan, album? How does the choice of material and medium affect the result?

Subject. What is the subject of this painting? Is it traditional or new? Totally serious or partly fun? What did it mean in the era when it was painted? What does it tell us about Japanese culture?

Artist and Purpose. What do you know, and what can you learn, about the artist? Was he or she a professional? Or a monk, poet, or scholar? Why do you think this work was painted? For a patron, for sale, for a friend, or simply for the joy of painting?

Style. Does the style refer to a past tradition? If so, has the artist followed tradition completely? Emphasized only certain aspects of it? Changed some elements? What is the brushwork like? Simple or complex? Free or restrained? Bold or delicate? Is the composition symmetrical or asymmetrical? Is there an interesting use of empty space?

Total Impression. How do the medium, the subject, and the style interconnect? Is the painting effective in expressing a dominant emotion or artistic vision? Does the painting show every aspect at once, or does it have hidden riches?

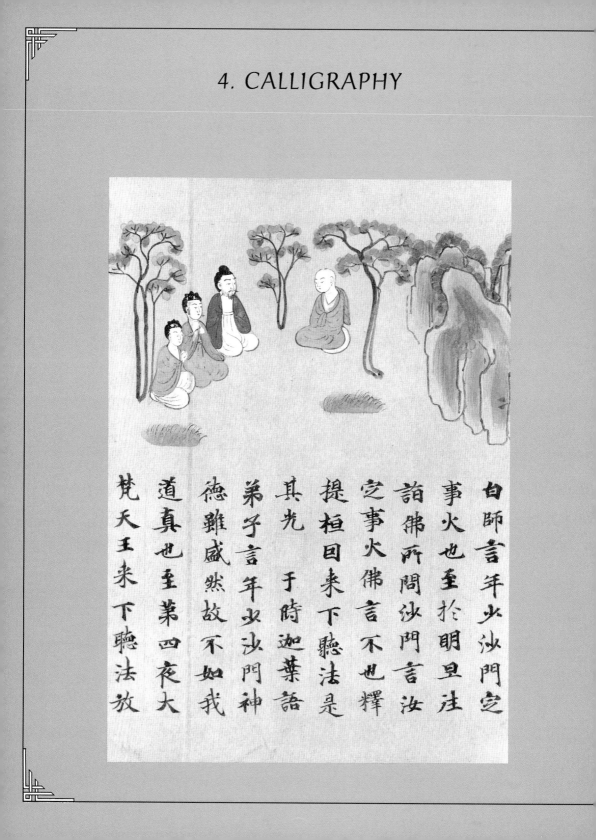

白師言年少沙門定
事火也至於明旦往
詣佛所問沙門言汝
定事火佛言不也釋
提桓因来下聽法是
其先 于時迦葉語
弟子言年少沙門神
德雖盛然故不如我
道真也至菜四夜大
梵天王来下聽法放

*C*alligraphy has enormous impact on some viewers, but is all too easily dismissed by others. Some people feel that it is too complicated to enjoy, or they are put off by being unable to read it. Yet it has a direct visual dynamism that can be riveting to those who give it a chance. More than reading the words, it is experiencing the dance of lines and forms that creates the beauty of calligraphy.

Until this century, all Japanese who learned to read and write used brush, ink, and paper or silk, the tools of calligraphy. Today, after the introduction of pens, pencils, typewriters, and computers, writing with the brush has become purely a form of art, and it is practiced by everyone from schoolchildren to people in their eighties and nineties. Japanese believe that it is never too early to start, and also that age brings maturity not only to personal character, but also to the expression of that character in writing. We have observed in the works by the husband and wife Taiga and Gyokuran (see figures 34, 35) how their calligraphy added important personal elements to their painting, and indeed Japanese painting depends on the same technique— brushed ink on paper or silk—as calligraphy.

Opposite:
37. *Sutra of Cause and Effect* (section). 8th century. Ink and color on paper, 10¼ × 7⅞″ (26 × 18.5 cm). Collection Kimiko and John Powers

Seen for itself, calligraphy is of all Japanese arts the most focused on the play of forms in space.

Japanese calligraphy began with the written form of the Chinese language, in which each word has a separate character. This meant that to be literate, early Japanese had to learn thousands of distinct forms from the total of more than fifty thousand Chinese characters. As we shall see, the Japanese gradually evolved their own written language from the Chinese forms, but even today much calligraphy in Japan is composed purely with Chinese characters. In standard script these require from one to seventeen strokes of the brush for each word, but there are also four other script forms, ranging from the beautiful formality of ancient seal script (still used on the red seals of the artists) to the fluent energy of cursive script. Therefore the possibilities are endless for creating different characters in different scripts in different combinations, far from our own visual limitations of twenty-six letters and ten numerals. Chinese and Japanese calligraphy is an art of infinite delight.

Early Calligraphy in Chinese and Japanese

Calligraphy was introduced to Japan, along with Buddhism, from China and Korea in the sixth century. Until that time, Japanese people had no way to write their own language. It is no surprise, then, that many of the earliest surviving Japanese writings are Buddhist *sutras* (sacred writings), copied from Chinese examples. One

of the most fascinating is the *Sutra of Cause and Effect*, the story of the life of the Buddha. This was used as a teaching tool by early Buddhist monks in Japan, and illustrations were placed on the top half of the scroll, perhaps for those who could not read the Chinese characters.

One short section from an eighth-century handscroll in a private American collection (figure 37) describes the Buddha after his enlightenment speaking with three Brahmins. The story in this section is that the Buddha was preaching when a great light descended to earth. One of the three Brahmins says that the Buddha worships fire, but he replies that it is merely the brightness of the Hindu god Indra coming to hear the Buddhist law. At this the Brahmin contends that Buddhism is not equal to his own Hindu path. The next night, the Hindu god Brahma descends to hear the teaching, giving forth great radiance, and eventually the three Brahmans are converted to Buddhism.

The painting is extremely simple, showing the Buddha and the three Brahmins rather than supernatural events, and complements the calligraphy below. The text is entirely composed of Chinese characters, eight to a column, written from top to bottom, right to left. There was no attempt to express personal emotion in the calligraphy; the artist wrote the sacred Buddhist text boldly and legibly in a traditional form of regular script. Each stroke of the brush is firm and confident. To enhance the rhythm of the calligraphy, the horizontal strokes tend to be thinner than the verticals, and occasionally a horizontal line is extended to the edge of the imaginary square around each character. The ample space, both between characters and between columns, contributes to a feeling of respect for each word of the *sutra*.

One character was cut out from the text, and a study of the original *sutra* shows that it was the word for "ear" or "hearing." Why should this character be missing? We cannot be sure, but the written Buddhist text was considered so sacred that someone who was growing deaf or who had an ear disease may have cut out this word to wear as an amulet. There are examples in both China and Japan of words in sacred calligraphy being used as charms, and indeed this method of writing, in which each word has a unique form and shape, must have seemed magical to early believers.

The importation of a system of writing was welcomed in Japan, but the Japanese language was structurally very different from Chinese. A single character for each word was well suited to the monosyllabic Chinese language, but Japanese is polysyllabic, with elaborate endings for verbs and adjectives. How could it be written with a single graphic form for each word? Over the course of several centuries, a system was devised in which Chinese characters were used for basic word elements, but simplified characters called *kana* were devised for phonetic elements such as word endings. Thus, Japanese as a written language came to be composed of both the complex Chinese characters and simpler *kana* syllable forms. This produced a pleasingly asymmetrical mixture of complex and simpler shapes, leading to a new Japanese aesthetic in calligraphy.

During the Heian period, this Japanese sense of beauty reached a new height in the calligraphy of five-line court poems (*waka*) on decorated paper, in the early twelfth century. Perhaps the

Opposite:
38. *Ishiyama-gire* (one page).
Early 12th century. Ink on silver, gold, and assembled dyed paper, 8 × 6⁹⁄₁₆″ (20.3 × 16.1 cm). Freer Gallery of Art, Smithsonian Institution, Washington, D.C.

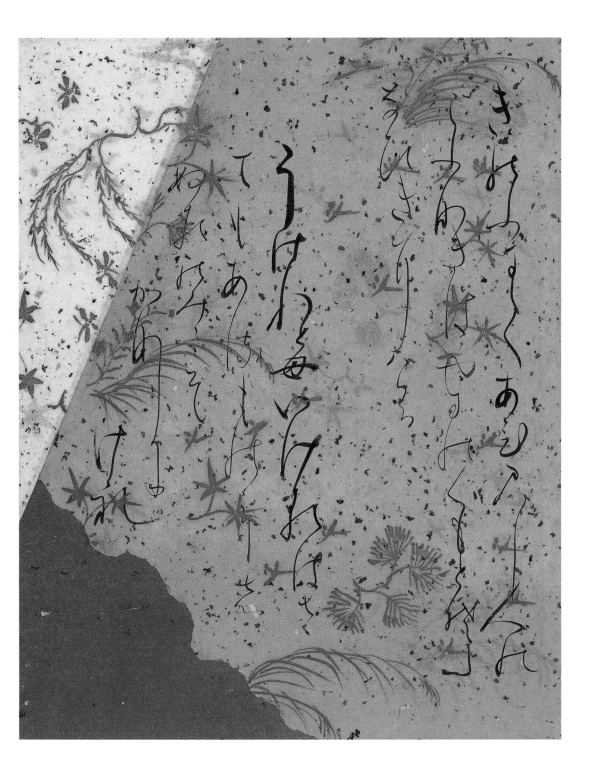

きよのことく　あひみてしかな

それよりも　もの　おもふ　人は

うくひすの　あだにてすぐる

てにあまて　しくれゆ

あめ
かな
け

most beautiful group of such calligraphy, transcribing an early-eleventh-century anthology of thirty-six great poets, is known as the *Ishiyama-gire*. This title is composed of the name of the temple where the works were once stored, the Ishiyama-dera, and the word *gire,* which means "cut segment." Several pages of the *Ishiyama-gire* are in American collections, including one splendid example at the Freer Gallery in Washington, D.C. (figure 38).

Here, the beauty of the work derives from the combination of exquisite brushwork and magnificently decorated paper, both organized in a strongly asymmetrical composition. The calligraphy, attributed to the court noble Fujiwara no Sadanobu (1088–1156), shows the elegance and refinement of the aristocratic Heian age. Lines vary from thick to thin, each of the two poems opening with bolder strokes and then attenuating to the finest of gossamer lines. The words are written with continuous brushwork, rather than the separated strokes seen in the *sutra,* and the effect is fluid rather than precise; the only pause in the flow of the writing comes before the last line of the second poem. In terms of movement, the poem is a ballet, the *sutra* a march.

The two poems are by the courtier Ki no Tsuriyuki (c. 876–946) and express longing for a lost lover or friend:

> *The loved one*
> *I could meet yesterday*
> * is gone today—*
> *wafted away*
> *like mountain clouds.*

> *Although I accept*
> *that to live is indeed like this*
> * it is only because*
> *a certain person has died*
> *that I am so deeply grieved.*

The paper is equal to the calligraphy and poetry in its beauty. First, there is the technique of collage, in which both cut and artfully torn papers have been joined. Then flecks of gold and silver leaf were scattered over the surface, and small designs of reeds, pine, and maple leaves painted in gold. Within this feeling of elegance, the poems were asymmetrically written. A calligraphic shape in the middle of the first line on the left echoes the total shape of the composition, like a broad arrow pointing to the left. The first poem stretches out in three lines, the second squeezes into five lines, but the strongest calligraphy on the first line of the second poem forms a central axis for the entire composition.

The *Ishiyama-gire* reflects the Heian-period custom of courtly lovers writing poems to each other in the most elegant style. This is the world captured in *The Tale of Genji* (see figure 24), but it was to crumble at the end of the Heian period, when warriors supplanted courtiers at the helm of the Japanese state.

Zen Calligraphy

The aesthetics of the Kamakura (1185–1392) and Muromachi (1392–1568) periods were quite different from those that led to the *Ishiyama-gire*. Although court poetry continued to be written, it was the simpler and more intense aesthetic of Zen that dominated much of Japanese art, and calligraphy by monks replaced that of courtiers in creative energy. Now, instead of delicacy there would be roughness, and rather than elegance there would be spontaneous force.

One of the most fascinating of Japanese Zen Masters was Ikkyu Sojun (1394–1481). He lived during an age when Zen had departed from its customary role as an alternative way of life to become the dominant cultural force in Japan. During the Muromachi period, Zen monks were in

charge of education, served as government advisors, and even led trading missions to China. The official sponsorship of Zen meant that the ideals of self-discipline, simplicity, and lack of ostentation pervaded many aspects of Japanese life. Zen aesthetics strongly influenced many forms of art, including ink painting (see figures 26, 28, pages 59, 60) and garden design (see figures 60–65, pages 116–26). On the other hand, because entering a Zen monastery became one route to power and influence, inevitably some monks were not sincere seekers of enlightenment. Ikkyu decried the Zen of his day, feeling it had become too much part of the establishment. He raised his powerful voice in speeches and sermons, but the deepest expressions of his vision are in poetry and calligraphy. He wrote a *waka* about the word *kokoro,* which means both "heart" and "mind":

> As for kokoro
> *there are no words*
> *that can define it*
> *but it can be brushed with ink,*
> *the sound of wind in the pines.*

Ikkyu's calligraphy matches his unique personality. Bold, dramatic, not bound to conventional ideas of beauty, it expresses his intense Zen spirit. In one of his works consisting of a single column of text, a format often used by Zen Masters, he has written the name of the founder of East Asian Zen, *First Patriarch Bodaidaruma Great Teacher* (figure 39). The eight characters run together, so it is difficult to tell where one ends and the next begins. The lines are rough and angular and create a great deal of the effect called "flying white," where the paper shows through the quick, dry brushwork. This creates a sense of movement, energy, and spontaneity.

One of the best ways to see the artistic qualities of calligraphy is through comparisons. Two

centuries after Ikkyu, the monk Ingen (Yin-yuan in Chinese; 1592–1673) led a group of Chinese monks to Japan, where they began the Obaku sect of Zen. Here, Ingen's calligraphy has almost the same text as Ikkyu's, merely omitting the third and fourth characters, and reading *First Patriarch Daruma Great Teacher* (figure 40).

Both are strong works by major Zen Masters, yet they are certainly dissimilar in style. Where Ikkyu's brushwork is rough, dry, and blunt, Ingen's is smooth, flowing, and massive. Ikkyu leaves no space between words; Ingen allows each character to stand by itself.

If we look more closely, there are other significant differences between the two works. For example, Ingen adds his signature on the left, followed by two typically large Obaku-style seals, while Ikkyu's work has only one seal in the lower left. The most important difference, however, is in the artistic process itself. Ikkyu seems to be writing very quickly, allowing the brush to run out of ink as he continues the strokes. Although Ingen also creates some flying white (such as in the third character), in general he seems to move his brush more slowly and deliberately. Most telling, however, is the way each Zen Master ends the final stroke in the different characters.

In Ikkyu's case, the last stroke of a word may swing out to the right side (fourth and seventh characters), fly into the air (fifth character), or move bluntly downwards (last character). In contrast, every final stroke by Ingen curves back toward the center, with the final curve swinging back the most fully. This gives his calligraphy a sense of control and balance totally different from Ikkyu's dramatic brushwork.

What is the result in each case? Which of the two monks would you guess was more impetuous in personality, which more poised and serene? A more difficult question is: Which is

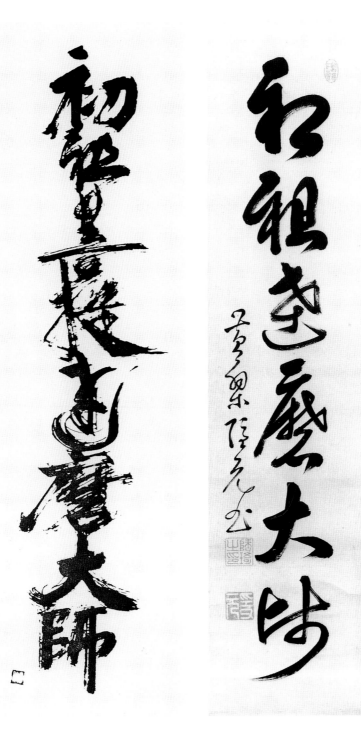

Far left:
39. Ikkyu Sojun
(1394–1481). *First Patri-
arch Bodaidaruma Great
Teacher*. Ink on paper,
51½ × 13⅜″ (130.8 ×
34.6 cm). Collection
Kimiko and John
Powers

Left:
40. Obaku Ingen
(1592–1673). *First Patri-
arch Daruma Great
Teacher*. Ink on paper,
41¾ × 11⅜″ (106 × 28.9
cm). Collection Kimiko
and John Powers

better? That depends on the viewer. Ikkyu seems to shout "FIRSTPATRIARCHBODAIDARUMA-GREATTEACHER!" while Ingen seems to chant "*First Patriarch Daruma Great Teacher.*"

Considering the different spirit in the two works, it may seem surprising that Ikkyu's calligraphy is actually in the standard (printed) form of writing, tending toward a slightly looser "running" script, while Ingen moves from "running" to "cursive" script. As a rule, the more cursive the writing, the quicker and more spontaneous it may seem, but here Ikkyu chose the short, abrupt, angular potential of regular script, while Ingen preferred the curving, fluid qualities of cursive script.

From this comparison, we can see that the differences in the two works, which originated from the different personalities of the two Zen Masters, come forth in many ways, including composition and spacing, type of script, speed of brushwork, and the movement either outward or inward of concluding brushstrokes. Both works honor Daruma and his experiential teaching of enlightenment, but each calligrapher expresses his spirit in his own individual manner.

This would be no surprise to people who enjoy the arts in Japan. It has long been believed that any kind of brushwork reveals the personality of the artist, and that calligraphy in particular shows each person's individual character clearly. For that reason, famous monks, poets, and statesmen of the past are admired through their writing, which conveys their inner nature to those of a different time. Even now in America, we can see the spirit of Ikkyu and Ingen as directly as if they were standing in front of us—perhaps more so, since people can hold back or disguise their nature in person, but not in their calligraphy.

Later Japanese Calligraphy

As the age of government support for Zen approached an end, there was a revival of interest in Japanese-style arts as had been practiced in the Heian period. One of the most significant masters of this period was Hon'ami Koetsu (1558–1637), who became renowned in calligraphy, pottery, and the connoisseurship of swords. He also befriended many artists, including the painter Sotatsu (d. 1643?; see figure 32). Koetsu and Sotatsu collaborated on a number of works that rival the great Heian-era poems on decorated paper, although they are rather different in style and spirit. Sotatsu provided bold and rhythmic paintings or woodblock designs on handscroll paper, over which Koetsu added his calligraphy of famous *waka* poems from the Heian and Kamakura periods.

One of the major collaborations between Koetsu and Sotatsu is the *Lotus Scroll,* based on the *One Hundred Poems by One Hundred Poets,* an anthology originally compiled by court nobles in the thirteenth century. Over the course of the handscroll, Sotatsu painted the life cycle of the lotus, from buds to blossoms to seed pods to desiccated leaves, and back to buds and blossoms. The calligraphy by Koetsu weaves around (and occasionally through) the painting in visual counterpoint (figure 41). Unlike the more delicate poems on elegantly decorated paper of the Heian period, the writing is now much bolder, in order to match Sotatsu's dramatic close-up views of the lotus painted in gold and silver on the white paper.

The final poem in the anthology was written by Emperor Juntoku (1197–1242) at the age of twenty. He recalls the days of court glory in the Imperial palace, before warriors moved the seat of government to Kamakura. The use of the word *shinobu,* which can mean both "vines" and "re-

41. Hon'ami Koetsu
(1558–1637) and Tawaraya So-
tatsu (d. 1643?). *Lotus Scroll*
(section). Ink on
decorated paper, height 13⅛″
(33.3 cm). Tokyo National
Museum

member" or "long for," gives the poem an added
poignancy:

> *Although the ancient eaves*
> *built of hundreds of stones*
> *are covered with vines,*
> *there still remains*
> *the spirit of long ago.*

Koetsu's calligraphy moves from thick to
thin in a regular, smoothly flowing rhythm. We
can sense the great confidence of the master in
every fluent stroke of his brush. Koetsu follows
the traditionally diagonal overall composition of
waka calligraphy, but he also instigates a complex
relationship with the painting. The writing occa-
sionally goes over Sotatsu's design, but more
often it echoes the vertical and curving lines of
the lotus stems and flowers.

Sometimes a thin stroke of the brush can be
more dramatic than a thick one. Here, the broad
area of empty space left by Sotatsu on the right is
bisected by the slender vertical line (the Japanese

syllable for *shi*) that seems to float in space, drawing attention to the important word *shinobu*. Another word that subtly stands out in the calligraphy is the Chinese character for *mukashi*, meaning "long ago." It is placed just under the central lotus blossom, and seems to hang suspended from the flower. The poem ends quietly two columns to the left, and to conclude, Koetsu added his signature surrounding the stem of the final blossom.

Sotatsu and Koetsu collaborated on several other masterly scrolls, one featuring playing, grazing, and prancing deer, another based on rising and descending lines of wild geese. Chinese poets had often added poems over paintings, but the two were not visually intertwined. The full artistic interconnections of calligraphy and painting were particularly enjoyed and developed by the Japanese, and these scrolls are among the masterworks of the genre.

When we look at the next work (figure 42), what might we imagine about the artist? Possibly a Zen Master? No, the calligraphy seems too decorative. A Japanese-style poet? No, it is composed of a single large Chinese character. A Chinese-style literatus? Now we are getting closer, for this is the work of Ishikawa Jozan (1583–1672), the scholar-poet-calligrapher who retired from government service to live in a rustic hermitage with a beautiful garden that he designed for the contemplation of nature (see figure 68). Almost all of Jozan's poetry is written in Chinese (not unusual in Japan), and at his Shisendo hermitage he hung paintings of his own selection of thirty-six immortal Chinese poets. Jozan's calligraphy is usually written in clerical script, an ancient Chinese form seldom used in Japan before his time. We can therefore imagine Jozan as an elegant scholar-artist living in antiquarian Chinese literati style in his rural retreat on the outskirts of Kyoto.

The illustration does not show Jozan's brushwork directly, but is rather a wooden panel into which the writing has been carved and inset with mother-of-pearl. Jozan's strongly architectonic calligraphy is well suited to being carved in wood, and his hermitage has many plaques of his calligraphy. Here the single word is "virtue," pronounced *toku* in Sino-Japanese. It is also the first character of Tokugawa, the ruling Shogun family in Japan, whom Jozan had served as a young man.

It is characteristic of clerical script that the brushstrokes are roughly equal in width, rather than thickening and thinning. There is one major exception, the so-called *na* strokes, which move diagonally down to the right or left. Here, both lower corners of the large character show the swelling and attenuation of these strokes, producing graceful shapes that help to soften the effect of the thick, even strokes in the rest of the character. The diagonals of the *na* strokes also alleviate the generally horizontal and vertical strokes that give this calligraphy its firmly structural (but slightly asymmetrical) balance.

In this example, as in all calligraphy, we can study the negative spaces as well as the brushstrokes. While the actual strokes are bold, angular, and thick, the empty spaces are smaller and more curved. Like the brushstrokes, these spaces are nicely balanced with each other. In particular, we can compare the square areas of negative space within the horizontal rectangle in the center right of the character. Each space has a slightly different shape, with the left square tilting left, the center balanced, the right tilting to the right. The negative areas at the bottom right are more complex, allowing the dots to float in space while preserving interesting shapes that look like a capital P, a hook, and an arrow point, as you read from left to right. Every negative space can be seen as a distinct shape, just like

42. Ishikawa Jozan (1583–1672).
Virtue. Wood inlaid with mother-
of-pearl, 14 × 17″ (35.6 ×
43.2 cm). Private collection

Right:
43. Diagram of negative spaces in
Jozan's *Virtue* (figure 42)

every brushstroke (figure 43). I am reminded of a story told by the harpsichordist John Gibbons: he was reading a musical score one day when a conductor came by and said, "The black is the notes; the white is the music."

The smaller, left side of the character for "virtue" is created of a dot, a slightly tilted dash, and a forceful diagonal *na* stroke. This dynamic shape is balanced and supported by Jozan's signature and two of his seals, aligned in an even column of form and space. This plaque is decorative, because of the use of mother-of-pearl, but it also reveals the absolute strength and control of Jozan's beautifully constructed calligraphy. We can well understand that this artist boldly and carefully planned out his refined life as a retired scholar-artist. As he wrote in one of his Chinese-style poems (translated by Jonathan Chaves):

> In this house, a craze for calligraphy and
> poems,
> Outside the gate, no tracks of horse or
> carriage. . . .
> My plan was simple—retire early.
> To this day I've had peace of mind.

The seals that have been carved into this plaque are a feature of most painting and calligraphy. They represent various art names (like our pen names) of the creator of the work, and occasionally also reveal other information such as the sect of Buddhism of a monk-artist, or a favored few words of poetry of a literati master. Over the centuries, the carving of seals changed from a craft to an art, and in the past three hundred years fine seal carvers have been recognized as calligraphers in stone, ceramic, metal, or jade. Almost invariably, the ancient form of Chinese writing known as seal script is chosen for engraving. This is due first to its formal beauty, and second to its use of even (rather than thinning and thickening) lines that are perfectly suited to carving.

While seal carving grew to be an important form of art, the Japanese did not follow the Chinese custom of allowing collectors and connoisseurs to add their seals to paintings or calligraphy. While this practice allows viewers to chart the history of a scroll through the ages, it can lead to dozens of seals covering an old scroll, sometimes to the point of disfiguring the work. The Japanese preferred to keep the surface clean and spacious, and so the seals one sees on Japanese paintings and calligraphy are those of the artist, forming part of the total design of the original work.

One of the leading masters of seal carving in the early nineteenth century was Hosokawa Rinkoku (1779–1843). He was also gifted in poetry and painting, but his seals were especially admired for their creative composition of characters and superb carving. Rinkoku was asked for seals by many of his artist-friends, but he also twice accomplished a tour de force of carving just for the sake of his own enjoyment, engraving in seals a long poem of the Chinese literatus T'ao Yuan-ming (365–427) entitled *The Homecoming*.

T'ao Yuan-ming had served as a government official before retiring to live in poverty as a farmer and to write poetry. He was much admired in later ages by both Chinese and Japanese literati. They not only enjoyed his poems, but also honored his decision to live for nature and art rather than seeking worldly or political success. *The Homecoming* begins:

> Returning home!
> Fields and garden all weeds—
> Why not return?
> Since I've been imprisoned by my own mind,
> Why be disappointed and grieve alone?
> I realize I can't change the past,

歸去來兮　　胡不歸　　奚惆悵而獨悲　　悟　　已往之不諫　　實　　迷途其未遠

田園將蕪　　既自以心為形役　　　　　　　知來者之可追　　覺今是而昨非

Top:
44. Hosokawa Rinkoku (1779–1843). *The Homecoming*. Seal ink on paper, various sizes. Private collection

Bottom:
45. Printed versions of Rinkoku's seal characters

But I know I can pursue a good future.
Not having gone far astray,
I now see clearly the past was a mistake.

As the poem continues, T'ao returns to his home and family, enjoying the quiet life of farming, books, music, and the change of seasons.

The nine seals shown here (figure 44) represent the first nine lines of the poem, starting as usual from the top right. This is calligraphy with the knife instead of the brush. Although the technique is different, the artistry is much the same—line and form, positive and negative spaces, creating a sense of movement on a two-dimensional surface.

For most calligraphy, seals provide the only touch of color. Therefore, they form a vital part of the total composition, like an exclamation point at the end of a sentence. Here, however, the seals make up the entire work of art, and Rinkoku's achievement is to offer variety as well as continuity in re-creating T'ao Yuan-ming's monumental poem within the small shapes of seals.

To show how the original characters of the poem look in regular script, these are given in figure 45. We can follow the artistic decisions that Rinkoku has made. How many characters should there be on each seal? He has decided to let each seal match one line of the poem, with from three to seven characters each. He also had to decide whether the seals should alternate red on white and white on red. That might have been too predictable a pattern, so the first six seals are all white on red, and then they begin to alternate.

For artistic variety, Rinkoku has used various forms of old seal script. He has also chosen seals of different sizes and shapes, most geometrical, but some free-form. Many of the seals were deliberately carved with uneven and slightly blurred lines, suggesting rubbings from ancient stones that have begun to crumble. In contrast, other seals are very sharply carved, especially the more difficult red and white seals in the lower left. The first four seals are almost the same size, but the very large fifth seal adds variety and emphasizes the line "Why be disappointed and grieve alone?" In these ways, Rinkoku turns seal carving into an expressive calligraphic art.

Calligraphy has not been restricted to the use of paper, silk, and seals. Another interesting kind of artful writing has been on ceramics. This art reached a high point in the late nineteenth century with the work of Otagaki Rengetsu (1791–1875), a *waka* poet, painter, potter, and calligrapher. In recent years, there has been a Rengetsu "boom" in Japan as collectors, curators, and connoisseurs have increasingly recognized her as one of the major artists in Japanese history.

Rengetsu's early life was marked by tragedy. Her first husband died, as did their three children. After she married again, her second husband and their daughter also died before Rengetsu was thirty-five years old. She then became a Buddhist nun. Increasingly noted as time went by for her calligraphy and poetry, she also began making ceramics to help support herself. Hand-forming the clay, Rengetsu created vessels for the tea ceremony, for Chinese-style tea (*sencha*), and for *sake* (rice wine) drinking. She added one of her poems to each ceramic, and sometimes a simple painting.

It is difficult to categorize Rengetsu's work, since it includes calligraphy, ceramics, painting, and poetry, but perhaps calligraphy is the binding force that unifies her art, since she included it in every medium that she attempted. Rengetsu developed two basic techniques for inscribing her pottery, either writing on the clay with glaze or incising the surface with a pointed bamboo

Right:
46. Otagaki Rengetsu (1791–
1875). *Sencha Teapot*. Glazed
stoneware, height 5⅞″ (14.9 cm).
Private collection

Below:
47. Morita Shiryu (b. 1912).
Dragon Knows Dragon. Gold
lacquer on lacquer screen,
44″ × 7′3″ (111.8 × 221 cm).
Private collection, Cambridge,
Massachusetts

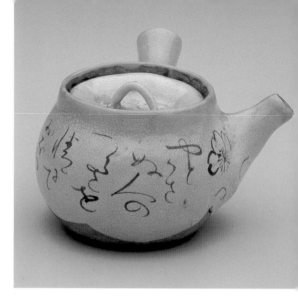

stick. One of her most celebrated works is a small teapot for *sencha* (figure 46). In this vessel, a few high-quality tea leaves would be steeped in hot water, and the tea would then be poured, drop by drop, into very small cups. After creating the shape out of clay and letting it dry, Rengetsu painted a few blossoms over the body and lid of the teapot, and wrote one of her most famous *waka*:

> Refused at the inn—
> *although I deeply felt*
> *this unkindness,*
> *in the hazy moonlight*
> *I slept under cherry blossoms.*

The poem expresses Rengetsu's ability to survive misfortune and still find beauty in the world. Her calligraphy exhibits a similar inner strength. The lines are thin and rounded but have a tensile strength that testifies to her resilience and fortitude. There is nothing showy about her writing, but it combines grace with controlled power.

Calligraphy has remained a significant form of art in the present century. Although Japanese children now learn to write with pencil or pen, they often take special calligraphy classes, and there are many exhibitions of both historical and contemporary calligraphy in museums, galleries, and department stores. Although one might have expected the art to decline, it is reaching new heights of popularity.

One of the leading contemporary masters of calligraphy is Morita Shiryu (b. 1912). He founded, and for many years edited, a magazine called *Bokubi* ("The Beauty of Ink"), which discussed and reproduced masterworks of calligraphy, including seal-carving, from ancient *sutras* to avant-garde works of the present day. Morita's own work is extremely free and dramatic. He often takes a single character and transforms it almost to the point of abstraction. One of his favorite words to write is *ryu* ("dragon"), which still retains the memory of its original pictographic shape; it is also part of his art name, Shiryu.

In his four-panel screen *Dragon Knows Dragon,* Morita has written with gold lacquer over a black lacquer background (figure 47). We can see traces of the dynamic movement of his huge brush, including the spattering of golden drops as he began the large dot on the second "dragon" on the right. The work is so pictorial that we may ask whether this is painting or calligraphy. In Morita's work, the distinction almost disappears, and his writing becomes a free play

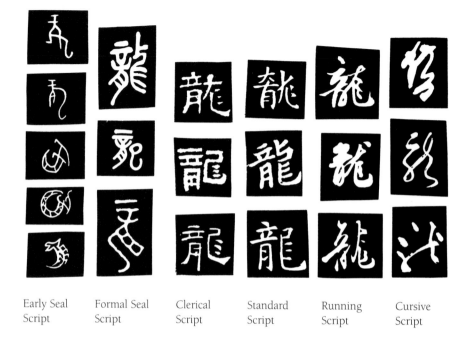

| Early Seal Script | Formal Seal Script | Clerical Script | Standard Script | Running Script | Cursive Script |

48. The word *dragon* in different scripts

of form in space. But if we examine the different ways that the word "dragon" has been written in the five Chinese scripts (figure 48), we can see how Morita has utilized the past as a basis for his own creativity. The same word on the right and left of the screen, "dragon," takes quite different forms, but the basic elements are retained, while the smaller "knows" in the center is also treated very freely.

Here, as in all fine calligraphy, we can examine the negative spaces as well as the forms themselves. These spaces help to balance the movement of the gold "dragon" on the left and the more concentrated power of the "dragon" on the right. We can also re-create the artistic experience in our own eye and mind, following the lively path of the brush as it hits, moves, swings, and lifts.

In his screen, Morita has altered the basic forms of the Chinese characters, but he is still guided by their fundamental sense of movement through·space. This transformation is the secret of fine calligraphy, and it may also be considered an underlying principle of all Japanese art. Just as Morita's bold, asymmetrical composition, dramatic brushwork, and sense of play all animate his work, it is ultimately this kind of expression of life and movement that distinguishes the finest Japanese art through the ages.

Key Questions When Looking at Calligraphy

Material and Format. What format has been used: hanging scroll, handscroll, fan, album leaf, or framed work? Is the calligraphy written on paper, silk, or another material? How do the format and materials relate to the style of the work?

Language and Script. Can you distinguish if the work is in Japanese or Chinese? Is it a formal script, with balance and a slow-paced rhythm? Or is it more free, with a sense of quick movement?

Text. If the text has been translated, is it religious? A secular poem? A scholarly work? Is it an original text by the calligrapher, or did he or she select an older text? How does the style of the calligraphy relate to the words?

Composition. Do the individual characters have normal or distorted shapes? Are they stubby or elongated? Strongly slanted or vertical and horizontal? Is the space between characters small or large? Regular or uneven? How do the forms relate to each other vertically? Horizontally? Does the calligraphy fill the surface boldly, or does it allow more empty space?

Brushwork. Are the lines smooth or rough? Thick or thin? Quick or slow? Tense or loose? Wet or dry? Similar or varied? How do the strokes begin? How do they end? Is there "flying white" where you can see the paper or silk through the strokes? Is this due to speed of brushwork, or to a lack of ink in the brush?

Total Impression. How do the different elements of the calligraphy relate to each other? What is the artist trying to convey? What kind of rhythm do you feel in the work—quick or slow, regular or varied? Do you sense the movement of the brush?

5. WOODBLOCK PRINTS

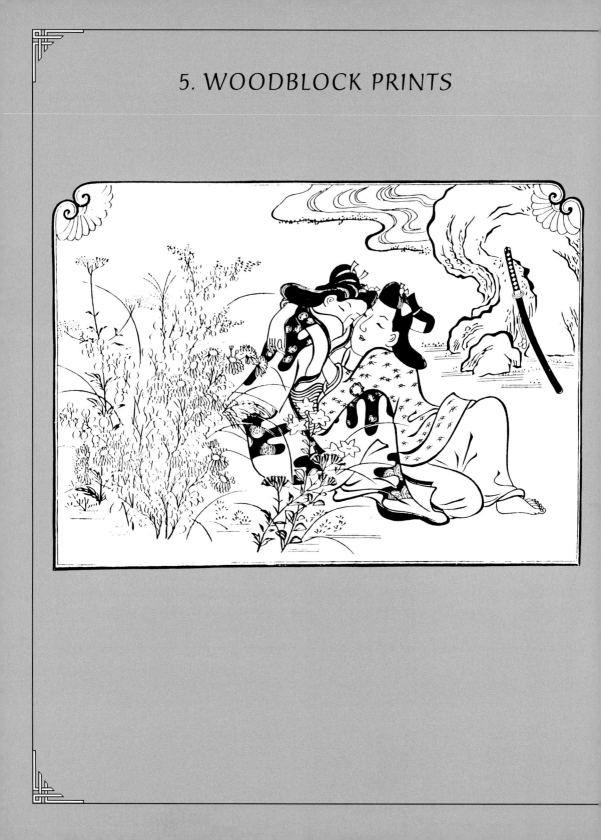

Ever since Japanese woodblock prints were introduced to Europe and America in the nineteenth century, they have been the most popular form of Japanese art in the Western world. The influence of these prints on the Impressionists and Post-Impressionists is well known; painters such as Claude Monet and Vincent van Gogh admired, collected, and were inspired by the works of Kitagawa Utamaro, Katsushika Hokusai, Ando Hiroshige, and many other Japanese masters.

Woodblock prints were not always so highly admired in Japan. Considered a plebeian form of art, they were not collected seriously until the past few decades. It has been estimated that at one time, ninety percent of traditional Japanese prints had reached the West, but in recent years Japanese museums and private collectors have been buying them back, and now there are magnificent collections in Tokyo, Osaka, and Kyoto as well as Boston, Chicago, New York, and London. Because prints were originally mass-produced and inexpensive, they are still widely available, although the finest impressions of the most celebrated prints can now cost staggering sums of money. Some astute collectors today are concentrating on contemporary prints, which are still relatively inexpensive, because they continue to reveal the genius of the Japanese in graphic arts.

The Floating World

The first Japanese woodblock prints were made at temples and given free to believers. They were generally images of deities or sections of sacred *sutras,* and they took the place of more expensive paintings and calligraphy. While they are often beautiful, they have been largely ignored by collectors and art historians. Instead, the focus has been on the secular prints of the Edo period (1600–1868). The primary subjects of these prints until the nineteenth century were either lovers or the most admired members of the so-called floating world—beautiful courtesans and handsome *kabuki* actors.

The concept of *ukiyo* (or the "floating world") came from Buddhism, which taught that worldly joys and aspirations are transient. Since beauty, money, fame, love, and even life itself are impermanent, detachment from desire and craving would lead to understanding and enlightenment. However, in the hedonistic world of Edo-period Japan, *ukiyo* took on a new aspect. If joys were indeed fleeting, why not savor them to the full while they lasted? The pictures (*e*) of these joys became *ukiyo-e,* scenes of the floating world. These were first shown in painted form, but before long *ukiyo-e* were also created on single-sheet woodblock prints.

Opposite:
49. Hishikawa Moronobu
(c. 1615–1694). *Lovers in an Out-
door Setting.* Woodblock print,
11½ × 13½″ (29.2 × 34.3 cm).
The Metropolitan Museum of Art,
New York. Harris Brisbane Dick
Fund, 1949 (JP 3069)

Cherry blossoms became a central image of transient beauty. They might last only a few days in spring before the first rain or a strong wind would destroy them, but they were admired all the more for their impermanence. A *haiku* poem written on a print of a young beauty by Ishikawa Toyonobu (1711–1785) conveys this bittersweet spirit:

> *Once again in love*
> *once again regrets, as fleeting*
> *as cherry blossoms.*

To celebrate such transient pleasures, woodblock prints of the most famous beauties and actors were produced by a succession of talented artists, engravers, and printers. These images were also first thought of as transient, similar to the popular songs or posters of our own society. Yet, like the best songs of George Gershwin and the Beatles, or the most creative poster art, the finest Japanese prints have given lasting pleasure to the people of many countries in the years since they were created.

The first great print artist was also a master at painting screens and scrolls. His name was Hishikawa Moronobu (c. 1615–1694), and his first signed and dated works appear about 1670. He was amazingly inventive; unlike many later print artists, he did not specialize in a favorite subject. Calling himself "the sparrow of Edo," Moronobu recorded the activities of the day, from major festivals and parades to life in the pleasure quarters, as well as occasionally portraying scenes from literature. Although the era before full-color printing is called the "Primitive Period of *Ukiyo-e*," there is nothing "primitive" about Moronobu's art. Whether in painting, prints, or book illustrations, his work is always as sophisticated as it is bold.

Among Moronobu's works are several series of prints showing lovers. Erotic prints were produced consistently through the history of *ukiyo-e,* and Moronobu's are among the most graceful and lyrical. In his depictions of his elegant era, both sexes are dressed in fashionable robes, but the men can be easily distinguished by the bald spot shaved in the center of the head. In Japan, it has always been considered more erotic to see lovers in their garments than to view bodies completely naked. Though this also was due in part to the love of beautiful textiles, primarily it reflected a feeling that suggestion was more enticing than straightforward revelation.

Moronobu was expert in suggesting the emotions of amorous couples, as well as their physical intimacies. *Lovers in an Outdoor Setting* (figure 49) displays his compositional skill, in which every element in the design echoes the flowing lines of the figures. The curves of the rock, flowers, and stream form a setting for the curves of the lovers' robes, until it seems that nature itself responds to their love.

Moronobu was also a master of negative space, such as the empty swirl that separates the couple from the rock and stream. The sword discarded by the young man rests at a gentle diagonal against the rock, both to serve as a male symbol and to accent the compositional diagonal that defines and gives movement to the flowers, the lovers, and the rock with the stream.

The composition is so strong that we might at first miss the equal strength of Moronobu's flowing, thickening, thinning, and hooking lines. These have been expertly carved into and printed from the hardwood block by highly trained artisans. The pulsating outline of the rock contrasts with the gentler curves of the stream, but the most interesting contrasts of line are reserved to create a dynamic rhythm for the figures. These can be seen, for example, in the three "nail-head" strokes at the folds of the

young man's leg, the hooking line below them, and the strong, arched line of his knee above them.

The lovers are defined both as a couple and as individuals. The young woman sits more upright, and shyly buries her chin in her inner robe. The young man, more assured, twists around boldly toward her, one hand negligently around her shoulders while the other explores within her clothes. Her robe's wavelike pattern suggests fingers reaching out, while the repeating pattern on his robe, probably a blossom, also resembles the written word for "woman."

The scene is contained within a double outline, with shell-like forms in the upper corners. Curiously, the left shell has ten sections, the right side only nine. Since this print seems to be from an original set of twelve, it may represent the tenth month (corresponding roughly to our November); the plants—bush clover, chrysanthemum, gentian, and autumn grasses—would be appropriate for that month. Because late autumn always carries with it a sense of sadness, this print of happy lovers has a subtext: the cold of winter is not far away.

In Moronobu's day, some prints were hand colored, but his dynamic composition and line can be seen most strongly in black-and-white. The later advent of full-color printing brought many opportunities for artists, but like all changes in art, it lost as it gained. The strength of line and form would never be seen as clearly in Japanese prints.

The transition to full-color printing took place in the year 1765. A group of young playboy-poets wanted to send an unusual New Year's greeting, and so they commissioned the artist Suzuki Harunobu (1725–1770) to design special prints that would include both their poems and a hidden calendar. Unlike our own system, in which the longer and shorter months are fixed, Japan had a system that included a moveable New Year's Day (generally occurring in our late January or February) and changing long and short months. The government had a monopoly on printing calendars, so the young poets thought it would be daring to include calendrical information on their greetings. To make them even more special, they insisted on full-color printing on high-quality paper.

Harunobu obliged. Hiding the information about long and short months in such areas as the texture of a wooden bridge, he produced prints of beautiful young women who exemplified the aesthetic of the day. Rather like the development in this century of color movies and then color television, once started there was no stopping, and soon the *ukiyo-e* public was swept up in the fervor for *nishiki-e* (brocade prints). Harunobu became the most successful *ukiyo-e* master of his day, and he is still among the most popular artists in Japanese history.

Girl Viewing Plum Blossoms at Night (figure 50) is one of Harunobu's most charming designs, showing a young woman on a veranda holding up a lantern to see the first spring blossoms. The young beauty appears delicate, almost fragile in her gentle curves against the powerful geometry of the setting. Her figure is set off by the black background, while other elements of the composition are minimal; even the plum tree is shown only by one section of the trunk and one branch. Yet, as in much Japanese art, the seeming simplicity of the composition conceals great mastery.

Harunobu's composition is based on two opposing diagonals. The dark red railing of the veranda sets off the motion of the hand and eye of the young woman along the diagonal of the lantern to the continuing diagonal of the branch. The velvet-black negative space is also beautifully handled, with one section of the plum tree's

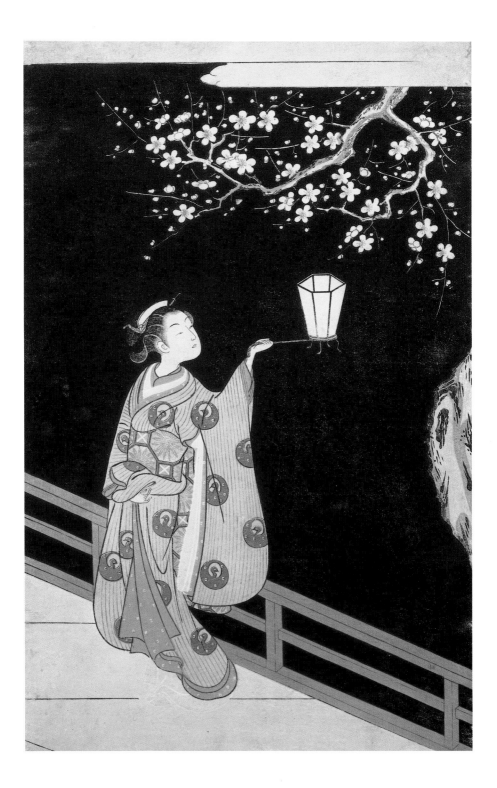

trunk balancing the form of the young beauty, who wears a robe of a similar color. Harunobu has actually borrowed a compositional device from the Chinese-style paintings popular in Nagasaki at this time, with the tree bending in and out of the composition to create a space cell for the main theme of the picture.

Every aspect of this print is extremely elegant. The paper, for example, is of higher quality than in most Japanese prints, and the colors are pure and delicate. Although difficult to see in a reproduction, the white under-robe and footwear of the young woman are printed in an embossing technique, creating a slight three-dimensionality to the print.

The works of Harunobu raise the question whether an artist only captures the prevailing sense of beauty of the time, or instead helps to create that aesthetic. The delicate, childlike, slender and serene beauties in Harunobu's prints certainly represent the feminine ideal of his age; other artists were forced to copy his style in order to survive. But did Harunobu create this type of beauty, or did he merely follow fashion? This is, of course, a chicken-or-the-egg kind of question, but it has important ramifications. Popular arts in any culture certainly represent the taste of the times, but through their dissemination they can also become extremely influential in creating models for an entire generation.

But art can do more. In nineteenth-century France, Impressionism offered nothing less than a new way of seeing; this was why it was at first excoriated by many critics. Yet Impressionism wasn't entirely new; it had been influenced by Japanese *ukiyo-e*. Taking this Harunobu print as an example, we can see several important aspects that influenced the French painters. First, the subject matter itself is a scene from daily life, from the world of entertainment, rather than a historical, official, or "important" subject. Second, there is a powerfully asymmetrical composition instead of a centralized focus of interest. Third, Harunobu made use of a completely different kind of space from European one-point perspective. He created his space in part through colors that are flat, rather than shaded, so that there is little sense of volume. Even more significantly, parallel lines do not always get closer as they recede. Quite the opposite—the railing behind the young woman actually becomes slightly wider as it moves back, upwards and to the left, unlike what the eye would see from a single position. Other prints take this V effect even further. In this they are remote from the great achievements in perspective of the Renaissance.

Renaissance perspective sees the world like a camera, with a single eye in a fixed position. We have now accepted this kind of perspective as "realistic," and it is extremely convincing for certain kinds of seeing, but not for all. For example, it stations the viewer in a particular place, but what if the viewer wishes to move, to see the scene from more than one position?

East Asian art can offer multiple perspectives, including simultaneous views of different parts of the scene from different positions. In his prints, by making supposedly parallel lines move apart as they recede, Harunobu creates a kind of reverse-perspective that invites the viewer into the picture. Looking at this print, we are encouraged to become part of the scene being depicted,

Opposite:
50. Suzuki Harunobu (1725–1770). *Girl Viewing Plum Blossoms at Night*. Woodcut, 12¾ × 8¼" (32.4 × 21 cm). The Metropolitan Museum of Art, New York. Fletcher Fund, 1929 (JP 1506)

and to take part in the floating world of ephemeral beauty.

The ideals of beauty are themselves transitory. Thirty years after Harunobu's first full-color prints, a different vision of feminine beauty was portrayed by another great master of *ukiyo-e*, Kitagawa Utamaro (1753–1806). No longer are women so youthful and delicate. Instead, Utamaro depicts them as taller, more robust, more mature, and full of individual feelings and emotions. This must represent a general change of taste between the 1760s and the 1790s, but it also reflects the individual ability of Utamaro to show particular faces in a range of particular expressions, such as coquetry, loneliness, delight, concentration, and weariness.

Where Harunobu had shown emotion by positioning delicate figures against geometric backgrounds, Utamaro is more direct. He frequently shows close-up views of women, concentrating on the tilt of the head and on the expression of the features. His women range from courtesans, to mothers with babies, to women diving for abalone. When he shows beauties of the pleasure quarters, he can express not only the haughtiness of the highest-ranking courtesans, but also the brutal life of the lowest class of prostitute, the so-called *teppo*. This word meant "gun" or "musket," and was also used in slang to refer to the *fugu* (blowfish), which could be deadly poisonous. Therefore, the name *teppo* suggests a certain amount of danger.

Utamaro's portrait of a *teppo* (figure 51) shows her with disheveled hair, exposed breasts, and a kind of tissue paper in her mouth, all of which indicate a recent sexual encounter. The print is the last in a series entitled *Five Shades of Ink from the Northern Provinces,* referring to five levels of courtesans. The *teppo* is the lowest, but Utamaro's attitude toward his subject is not merely sardonic. Despite the inelegance of her

51. Kitagawa Utamaro (1753–1806). *Teppo.* Woodblock print, 14¾″ × 9⅞″ (37.5 × 25.1 cm). Private collection

pose, she has a strong and compelling presence as she stares unseeingly ahead. Utamaro portrays a real human being; this is a print that not everyone may admire, but few can forget.

Just as Utamaro brought forth individual sensibility, a form of psychological realism, in his prints of women, so did the most mysterious figure in Japanese art in creating prints of *kabuki* actors. This artist signed his prints "Sharaku," and debates about his identity continue to the present day.

Sharaku appeared from nowhere, produced a large number of prints over the course of less than twelve months in 1794 and 1795, and then disappeared completely. He was possibly another artist using a pseudonym, or perhaps a member of a higher class, or an actor, or a foreigner. No one knows, although books continue to be published in Japan with the latest theories—including claims that Sharaku was a Dutchman, or was only fourteen years old, or was a samurai, or that Sharaku was (or was not) this or that famous artist.

The actual information is extremely limited. Unlike other print designers, who began by producing inexpensive prints or book illustrations, Sharaku immediately created the most expensive kind of prints, often with costly mica backgrounds, for the leading publisher of the day. His designs show great artistic skill, and they all depict scenes from the world of *kabuki*. The power of his depictions might have been too strong for the public; this is often given as the reason why he stopped making prints. But if this were true, why were so many different designs issued during his one year of production? Perhaps it is best to enjoy the mystery, instead of trying to solve it, and simply to regard the prints as among the most astonishing of all those produced in Japan.

Sharaku's depiction of the actor Ichikawa Ebizo (figure 52) is one of his strongest designs.

It is a bust portrait, with most attention concentrated on the face. Like Utamaro, Sharaku eliminates anything unnecessary, and as a result there is nothing to distract us from the individual actor and his dramatic facial expression. Ichikawa Ebizo, also known as Danjuro V, was one of the most famous actors of his time, excelling in highly theatrical parts such as noble and swashbuckling heroes or dangerous villains.

Although the name of the *kabuki* play is known, there is some controversy about which role Ebizo enacts in this print. Some authorities believe he is portraying a Noh actor who is driven to suicide because of his daughter's disgrace. Other experts believe the role is of one of two evil brothers who cause the death of the Noh actor. In any case, the power of Ebizo's personality is apparent through his staring eyes, arching eyebrows, and curled mouth. The parallel gray lines of the under-robe lead down to the twisting hands of the actor, a sign of his intense concentration. But is he plotting trouble, or lamenting his sad fate?

Sharaku creates the face of Ebizo with a series of curves. Crescent eyebrows, half-round eyes, hooked nose, S-curved cheekbones, and rounded chin all serve to define a very particular countenance. The hook at one end of the mouth, possibly a sneer, is the most decisive line, and Sharaku strengthens it by adding deep black to the original gray. Reinforcing this black curling line are three gray lines suggesting the cheek of the actor, while a black dot on the other end of the mouth adds a touch of asymmetrical balance to the face.

This print makes a fascinating comparison with the Utamaro *teppo* just seen (figure 51). Both are three-quarter profile, close-up views with the figure facing to our left; both are built from diagonals; and both give powerful portrayals of the floating world. But the differences are

strong: one figure is crushed by her life, the other creates a powerful presence. Utamaro portrays the *teppo* slumping into one corner of the composition, while Sharaku allows the actor to take center stage. The curving lines of the prostitute's draperies seem flaccid, compared with the bold color of the background. In contrast, the brisker lines of the draperies on Sharaku's actor are set against a silver mica background that enhances the forcefulness of the pose. The hair, the eyes, even the signatures of the artists seem to echo the energy or laxity of the poses.

The intense close-up depictions by Utamaro and Sharaku marked the climax of prints of courtesans and actors. Although later artists would continue to depict these subjects, there were no further great innovations or major new directions to explore, and the focus of *ukiyo-e* changed to a different theme: the beauties of nature in Japan.

Landscapes of Hokusai and Hiroshige

Hokusai and Hiroshige, the two greatest *ukiyo-e* artists of nineteenth-century Japan, each designed thousands of prints that included every imaginable subject. But both became famous, and remain beloved, primarily for their landscape prints. Despite their similarities, there was a great difference in outlook and vision between

the two masters. Each found a major subject: for Hokusai, it was views of Mount Fuji; and for Hiroshige, the stations of the Tokaido road. Views of the great mountain demonstrated Hokusai's power of composition, while scenes of travel showed Hiroshige's poetic sensibilities.

Katsushika Hokusai (1760–1849) had a long and successful career as a painter, print designer, and book illustrator before he first conceived his Fuji prints. These did not appear until the early 1830s, when the artist was in his seventies. It was immediately clear that he had found his great subject; originally intending to design a series of thirty-six prints, Hokusai added ten more, and a few years later he issued a set of three woodblock-print books with one hundred more views of Fuji.

How could a single mountain inspire so many designs? Hokusai took a broad view of his subject. Sometimes Fuji fills the picture, whether in clear weather or during a storm. In other prints, Fuji remains in the background of urban or rustic scenes of birds and animals, travelers, merchants, workmen, pilgrims, fishermen, or farmers. Whatever the foreground theme, Fuji creates a bold shape somewhere in the print, and unifies what might otherwise become a miscellany.

The most celebrated of Hokusai's designs, and very likely the most famous Japanese image in the world, is the print entitled *Under the Wave of Kanagawa,* popularly known as *The Great Wave* (figure 53). This image, which is said to have inspired Claude Debussy's tone poem *La Mer,* has become so well known that we may think we already understand it and need look no closer. It seems the ultimate depiction of a wave's power, like a stop-action frame at the height of drama. Herbert Read, in *The Meaning of Art* (1933), expressed this view eloquently, writing about how we can identify with the wave:

Opposite:
52. Toshusai Sharaku (active 1794–95). *Ichikawa Ebizo.* Polychrome woodblock print with mica ground, 14⁷⁄₁₆ × 9¹⁵⁄₁₆″ (36.8 × 24.4 cm). The Metropolitan Museum of Art, New York. The Howard Mansfield Collection, Purchase, Rogers Fund, 1936 (JP 2650)

Our feelings are absorbed by the sweep of the enormous wave, we enter into its upswelling movement, we feel the tension between its heave and the force of gravity, and as the crest breaks into foam, we feel that we ourselves are stretching angry claws against the alien objects beneath us.

That is the primary view people have of this magnificent image. But every masterpiece invites multiple possibilities of understanding and appreciation, and if we look once again we may discover something new.

For example, keeping in mind what we have seen earlier in Japanese painting, it should be clear that landscapes offer us views of how we relate to and live in nature. Hokusai's view here seems forbidding. The people in the boats will be lucky to survive, yet they do not appear to show any panic. Instead, they seem to be bowing to the wave. In the traditional Japanese view, humans do not control or attempt to dominate nature, trying instead to live in harmony with all other creatures and the natural forces of the earth. This print represents an extreme case: the power of the elements is overwhelming. But the human acceptance of nature is vital to the print; without the boats it would still be powerful, but not so affecting.

We should also consider the role of Mount Fuji. If there were no Fuji in the print, somehow we might feel that the image lacked stability. Although Fuji is small, it is a crucial presence in suggesting that the scene in the foreground, a single instant in time, is part of a greater continuum, part of a world that is permanent as well as momentary.

The importance of Fuji in the design can also be seen by examining the total composition. It seems at first that the print is made up of curves, particularly the great wave itself and the reverse curve of the trough under the wave. But if we look more closely, the Fuji shape is also crucial to the design. It not only sits in the center of the trough, serene amid the turbulence, but it is echoed by the foreground wave just to the left; this, too, is a Fuji. We might even see the great wave itself as a kind of incomplete Fuji-shape, moving through time, rising on the left only to fall again on the right.

Seen in these ways, the print is not only the most dramatic portrayal in *ukiyo-e* of nature's restless power, but also a strong statement of the underlying relationships between humans and nature, and between the temporary and the lasting. The wave will fall in an instant, replaced by another wave and then another, but Fuji remains.

Hokusai reached a new level of artistry with his Fuji series, but it was in his temperament never to be fully satisfied with his work. Another artist might have considered himself content with such a series of masterpieces, but Hokusai continued to try to become more creative as an artist. In his three-volume *One Hundred Views of Mount Fuji* of 1834, he once again tackled the theme of Fuji and a great wave (figure 54). Here, an even more astonishing transformation of nature takes place, as flying plovers seem to be created directly from the reaching fingers of water. In his preface to the book, Hokusai wrote about himself at age seventy-five:

Since I was six years old, I've been obsessed with drawing the forms of things. By the age of fifty, I had produced a great number of pictures, but nothing I did before seventy is worth anything. When I was seventy-three, I finally began to understand the true nature of animals, birds, trees, grasses, fish, and insects. When I reach eighty, I will have made some progress; at ninety, I will have reached the deep meaning of things; at one

53. Katsushika Hokusai (1760–1849). *The Great Wave*. c. 1831. Woodblock print, 9¾ × 14⅝″ (24.8 × 37.1 cm). Honolulu Academy of Arts. The James A. Michener Collection (HAA 13.695)

不二

54. Katsushika Hokusai
(1760–1849). *Fuji and a Great
Wave*. 1834. Woodblock print,
10½ × 9⅞″ (26.7 × 25 cm).
Private collection

*hundred, my work will be marvelous; and at one
hundred and ten, every dot and line will become
truly alive.*

Hokusai did not live long enough to see his
entire wish become true; he died at the age of
eighty-nine. Nevertheless he was indeed, as he
called himself toward the end, "an old man mad
for drawing," and his incredible outpouring of
paintings, prints, sketches, and woodblock illus-
trations has been more appreciated in the West-
ern world than the work of any other Japanese
artist.

If Hokusai's prints are characterized by powerful compositions and intense energy, the prints of Ando Hiroshige (1797–1858) display his gentler, more poetic vision. Hokusai's *Thirty-six Views of Mount Fuji* was the most popular series of works of graphic art ever created up to his time. Hiroshige's *Fifty-three Stations of the Tokaido,* first issued in 1833–34, became even more successful. The blocks were printed again and again until they were completely worn out. They were then recarved and printed again. Thousands of copies of the Tokaido prints were made, and even then the public was not satisfied. Publisher after publisher went to Hiroshige and asked for a new series of prints on the same theme. He obliged, and created more than twenty complete sets of Tokaido images as well as books, individual prints, and even a series of erotic prints entitled *Bedrooms of the Tokaido.*

What was the Tokaido, and why were these prints so popular? Part of the answer is historical. The Tokaido road ran between the new capital of Edo (Tokyo) and the old capital of Kyoto. It was used by merchants, messengers, feudal lords on their required journeys to Edo, mendicant monks, pilgrims, and government officials. In addition, as the peace and prosperity of the Edo period lent stability to society at every level, the Tokaido became traveled more and more by people from all walks of life. A series of station towns was established so that those on the road could stop for food, a change of horses, or a night's lodging. As the early-nineteenth-century author Ikku Jippensha wrote in his novel *Shank's Mare* about Tokaido travelers:

> Now is the time to visit all the celebrated places in the country and fill our heads with what we have seen, so that when we become old and bald we shall have something to talk about over our teacups.

Because so many people were traveling on the Tokaido, prints could serve as souvenirs, records of travel, or even as the equivalent of postcards to give to friends and relatives. Scenes along the road were not only personal memories, however; they also represented the spirit of Japan itself, in cities, towns, and countryside. Hiroshige was able to capture the various features of the landscape, the changing seasons, the different times of day, and the shifting conditions of weather.

Even more important, he showed the activities of people of every social class, including farmers, artisans, and low-ranking merchants. Of all Japanese artists, it was Hiroshige who most sympathetically celebrated nature, including human nature, in the context of day-to-day existence. He did this by combining sensitivity to the particularities of place, time, season, and weather with his poetic spirit and gentle sense of humor.

Hiroshige's first portrayal of the forty-fourth station of the Tokaido, *Yokkaichi* (figure 55), shows his unobtrusive mastery of pictorial design. As in Hokusai's *The Great Wave*, the human figures are at the mercy of nature, in this case a strong wind. Unlike Hokusai, however, Hiroshige does not show nature as overpowering, but rather offers two different human reactions to the vagaries of the weather. One man chases his hat, blown off by the wind and rolling down to the lower left of the print. On the far right, another man stands on a bridge in contemplation. His cloak blows out horizontally as he steadies his body against the stiff breeze, but he seems to be looking back over the moor rather than ahead to his destination.

When we look at the man chasing his hat, we are caught in the movement of the scene, but when we look at the man on the right, we are stopped in time. This effect is produced by compositional means (figure 56). The diagonals on

東海道五拾三次之内 四日市

55. Ando Hiroshige (1797–1858).
Yokkaichi. 1833–34. Woodblock
print, 9⅞ × 14⅝" (25 × 37.1 cm).
The Metropolitan Museum of Art,
New York. Rogers Fund, 1918
(JP 514)

56. Compositional diagram of Hiroshige's *Yokkaichi* (figure 55)

the left create a sense of movement, while the horizontal, verticals, and empty space on the right offer a feeling of repose. Each balances the other, so our attention can move first left, then right, then back to the left.

Hiroshige offers such a convincing sense of ordinary life not only because of his sensitivity to place, time, weather, and everyday human activities, but also because of his mastery of line, form, color, and composition. And perhaps we could add another reason, his sense of humor. This is not the overt humor or sharp parody of other Japanese art, but rather a gentle smile at the touch of absurdity in all human behavior. Other artists might directly satirize our self-importance, but Hiroshige has a kind of sympathetic humor that allows him to present us just as we are, neither heroes nor villains. If our hat blows off, we chase it; if our cloak ripples in the wind, we may still take a moment to gaze off to the horizon.

Later Japanese Prints

Many critics and connoisseurs have written that the end of traditional Japanese life spelled the end to the great age of woodblock prints. When Japan opened to the West after the Meiji period began in 1868, the change to an industrialized, international society had far-reaching effects on Japanese arts. In terms of prints, one of the changes was the introduction of other forms of graphic art, including lithographs, etchings, engravings, and photography. Nevertheless, some artists continued to work in the woodblock medium, and they added new creative elements to the history of Japanese prints.

One of the masters of the early Meiji period (1868–1912) was Tsukioka Yoshitoshi (1839–1892). He lived during an age of violent change, and much of his work is turbulent, impassioned, and disturbing. Yet he was also capable of great

understanding and sympathy, although very different from the more gentle touch of Hiroshige.

One of Yoshitoshi's most famous series of prints is *Thirty-six Transformations* (also called *Thirty-six Ghosts*), designed and printed between 1889 and 1892. These dramatic subjects called forth the artist's vivid imagination and gave full scope to his artistic talent. Most of the themes came from Japanese literature and folklore, which are rich in supernatural legends and tales. The story of *The Fox Woman Kuzu-no-ha Leaving Her Child* (figure 57) is among the most touching.

The legend begins with the tenth-century nobleman Abe no Yasuna reciting poems near the great Shinto fox shrine of Inari, just outside the city of Kyoto. An exhausted fox appears, tired from being chased by hunters eager for its liver (then used as a medicine). The nobleman hides the fox in his robes, and the hunters chase onwards. Not long after, Abe meets a beautiful young maiden named Kuzu-no-ha ("kudzu leaf") and marries her. She bears him a son, but after three years she can no longer maintain her life as a human, despite her love of the nobleman. She knows she must end her human existence and return to life as a fox (in other versions of the story she must die), and she appears to her husband in a dream to reveal the truth to him.

It is always interesting to see how artists portray narrative scenes. Which part of the story will they choose to depict? Yoshitoshi has picked the most poignant moment for the fox woman, when she realizes that she must depart from her husband and child. This print expresses two different levels of reality simultaneously. We see a woman dressed in a kimono, with her son crawling behind her, but her shadow on the paper *shoji* sliding door is that of a fox. Meanwhile, kudzu leaves trail down from the roof, and the simulated eating away of the edges of the paper

suggests the impermanence of life, and even of the print itself.

The legend is grounded in the traditional Japanese belief in the ability of some animals, including foxes, to transform themselves into humans. However, these transformations, whether for good or evil, cannot last. The story in this case is not entirely sad; the young boy grew up to become a famous astrologer who was to cure the Emperor Toba of an enchantment from a less benign fox-woman.

Although Yoshitoshi's prints demonstrate his unique sensibility, he still worked in the established woodblock style. Japanese artists of the twentieth century have faced a more fundamental choice: whether to create in some form of traditional art, or to follow international (primarily Western) styles and formats. One master who was able to adopt certain Western influences while still remaining thoroughly Japanese in spirit was Munakata Shiko (1903–1975). He was born in the farming community of Aomori in northern Japan, the third of a blacksmith's fifteen children. Local festivals inspired Munakata to create painted lanterns and banners as a young man, and he also tried oil painting. His early ambition was to be the van Gogh of Japan, but after some years, he reflected that van Gogh had been influenced by Japanese prints, so why should he not devote himself to this great traditional art?

From the age of twenty-five, Munakata turned his attention primarily to the woodblock

Opposite:
57. Tsukioka Yoshitoshi (1839–1892). *The Fox Woman Kuzu-no-ha Leaving Her Child.* Woodblock print, 15⅝ × 9″ (39.7 × 22.9 cm). The Nelson-Atkins Museum of Art, Kansas City, Missouri. Gift of Mr. and Mrs. Charles A. Duboc (F89-7/13)

medium, but unlike earlier Japanese print artists, who created designs that were then carved and printed by others, Munakata did all facets of the work himself. He believed that the process of carving wood could not be separated from the creation of the image. He commented:

> The block is a demon. Something always happens when I take up the chisel and begin to carve. . . . The demon takes over and doesn't pay any attention to the drawing. Sometimes I paint right on the block, and still I never know what will happen when I start carving. It just happens by itself. Through the years I have learned to let it happen as it will. I can't fight it.

It was from this point of view that Munakata remarked that he was not responsible for his work, a strange statement until one realizes that he meant that his art proceeded from inside himself, rather than from his conscious control.

A large print, *Ananda* (figure 58), from one of Munakata's most famous series, *Ten Disciples of the Buddha,* displays his great power and energy. The figure fills the paper with large areas of black. Strong lines are roughly cut, as the artist saw no need to smooth out the forms. Small traces of ink show up on the white areas, since Munakata did not bother to carve away every inch of the unprinted areas. The result is a sense of immediacy, of process rather than product, and of great energy and force.

Ananda, the cousin and personal attendant of the Buddha, was considered foremost in heeding and later compiling the Buddha's teachings. Here Ananda bends his head down, holding one

58. Munakata Shiko
(1903–1975). *Ananda.* 1938.
Woodblock print, 35 × 8½" (88.9
× 21.6 cm). Private collection

hand in the gesture meaning "Have no fear." The fingers of the two hands make a strong graphic pattern, while other patterns of black and white are carved into the drapery to create powerful and intriguing geometric forms in white against the black of the robe. Ananda's diamond-shaped mouth is barely touched by his single-line nose, showing how Munakata worked in utmost simplicity whenever he could restrain his ferocious imagination. Once again we can compare the image with that of Utamaro (see figure 51), who showed the head of the *teppo* similarly leaning forward with a contemplative look. The difference is in the gentle self-possession of Ananda, stepping forward firmly, compared with the resignation of the prostitute, whose life is clearly beyond her control.

Munakata may well have been influenced by German Expressionist woodblock prints, which also featured roughly cut, forceful images. But here, the subject matter is Buddhist, and the dramatic power of form is balanced by a sweetness of spirit that is one of Munakata's personal characteristics. Over the course of his career, he created a large number of woodblock prints with Buddhist subjects, recalling the origin of printing in Japan, where inexpensive images were first made for parishioners at Buddhist temples. Other favorite subjects for Munakata were roly-poly nudes full of natural exuberance, and illustrated Buddhist *sutras*, in which he closely integrated calligraphy and pictorial images. Above all, Munakata's works display his intense and joyful creativity. It is said that he would send empty screen panels to the sites of his painting exhibitions, and the night before the opening he would fill them with color and form. Even in his final years, almost blind and dying of cancer, he continued to carve and paint images bursting with energy and delight.

The transformation of Japanese prints has been taken one step further by another twentieth-century master of graphic arts, Toko Shinoda. Born in Manchuria to Japanese parents in 1913, she was taken to Tokyo the following year and began practicing calligraphy at the age of six. Fiercely independent from her childhood, she refused to wear a school uniform or to attend group art classes. Encouraged by her father, from 1930 to 1945 she made a thorough study of traditional calligraphy on her own, and at the end of World War II she began to work in abstract painting.

Shinoda's work became widely exhibited, and was shown at New York's Museum of Modern Art in 1954. She moved to New York City in 1956, but returned to Japan two years later. Beginning in 1960, she has created a number of works of graphic art, displaying both her calligraphic training and her skill in nonrepresentational art.

Working in the medium of lithography, Shinoda combines elements of the international abstract tradition with particularly Japanese qualities. Like all nonrepresentational artists, she must balance her artistic forces so that they themselves become the "subject" of the work. In *Fresh* (figure 59), a work titled by the artist in English, two rectangular forms become interrelated both by their placement on the paper and by calligraphic lines that barely touch.

Looking more closely, we can see that Shinoda has taken advantage of the medium of lithography, or printing from stone, to create unusual textures. The seemingly solid rectangles are actually floating layers of color and tone on the paper. The upper rectangle is made up of overlapping forms of celadon green and mottled ink, while the lower shape is a large patch of gray and a larger, seemingly folded-over rectangle of semi-transparent, speckled ink. Shinoda may have created the mottled texture by using some kind of

Fresh Toko Shinoda 41/50

59. Toko Shinoda (b. 1913).
Fresh. Lithograph, 15 × 11⅛″
(38.1 × 28.3 cm). Private
collection

"resist" material on the stone, so that the ink would not flow smoothly; instead, it bubbles forth like hand-blown glass.

The flatness of the green and gray colors, enlivened by the rough edges of the brushstrokes, contrasts strongly with the stippled transparency of the overlapping rectangles. Even more dramatic, however, is the placement of the two main active areas, in the upper left and the lower right of the composition. Shinoda leaves a great deal of empty space, yet this space is not quiescent, but activated by the fact that it also forms rectangles. Furthermore, the empty area in the lower left is invaded by the scruffy black lines that escape the boundaries of the gray and green areas to reach toward each other. Do they suggest two separate beings reaching out to touch? Or are they perhaps like energy fields attracting and repelling each other? Are the black lines like antennae, feeling forward in space, or are they like tails, moving away from each other?

Finally, do these forms seem fixed in their places, or instead capable of moving over the surface of the paper? By her asymmetrical placement of forms, Shinoda certainly suggests a sense of movement, but we do not have to interpret the layering of shapes and stretching of lines as explicit meanings. One strength of nonrepresentational art is that it can allow viewers to escape from the limitations of subject matter, which may call forth fixed responses, into the world of pure form and color. Shinoda's genius is to incorporate the Japanese sense of contrasting textures, calligraphic brushwork, and asymmetrical composition into the universe of abstract art. In this way, she continues to represent the creative spirit of Japanese prints into the present day, and offers possible directions for the future of the graphic arts in Japan.

Key Questions When Looking at Prints

Artist and Design. What does this print tell us about the artist? Does it show some unusual feature? Is the composition strong? Are the lines decisive? Are the colors appropriate and evocative?

Impression. To tell an early from a later printing, we can ask: Are the lines sharp or blunt? Continuous or broken? Does the color fit completely into the outlines, or are there some small overlapping or missing areas?

Condition. Do the colors seem fresh or faded? (Be aware that most eighteenth-century prints have faded at least to some degree.) Are the margins complete or trimmed? Is the paper smudged or clean? Does the print have fold marks? Are there signs of any repair work? Does this print still display all the beauty that the artist, engraver, and printer originally gave it?

Context. What does this print tell you about Japan during the period in which it was made? Does it express the values of the "floating world?" Is it primarily realistic or idealistic? What does it indicate about attitudes toward nature, including human nature?

6. GARDENS

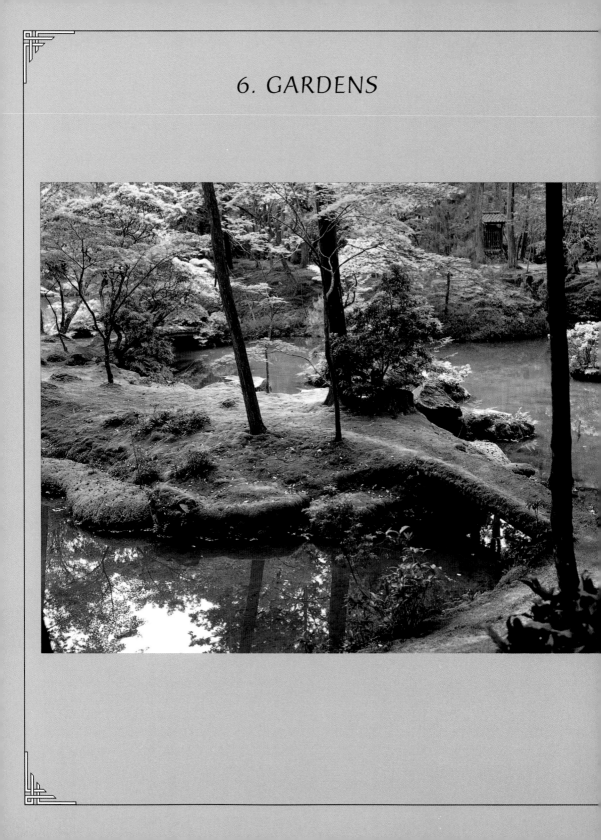

by Audrey Yoshiko Seo

Experiencing Japanese gardens can be a challenge and delight, bringing together many aspects of looking at Japanese art as well as adding new perspectives. Like paintings and prints, Japanese gardens can be viewed from single standpoints as total compositions, expressing the specifics of the particular season, time of day, and weather condition. Yet like sculpture and ceramics, they can also be seen from different positions and angles, and they rely heavily on a juxtaposition of textures. And gardens not only reveal a respect for natural materials, as other Japanese arts do, but are composed of nature itself, lovingly reworked to seem, somehow, even more natural. As organic art works which, in most cases, are actually walked through, gardens can surround and envelop the viewer in a total visual experience.

Unlike other Japanese arts, however, gardens need constant work to maintain their form. Because of their susceptibility to change, they can move the viewer through both time and space. As a result, viewers can continually look forward, sideways, and backward as they walk, because the perspective keeps changing. "Change," in fact, becomes the key word when discussing Japanese gardens. Besides being affected by variations in weather and seasons, most gardens consist chiefly of living, growing, and therefore constantly changing elements.

Opposite:
60. Saiho-ji. 14th century. Kyoto

Even gardens that at first may seem static, such as dry rock gardens, do change, both naturally over time and daily with human assistance.

Garden design has been dear to the Japanese since at least the eighth century. The word *niwa*, used today to mean "garden," first indicated a purified place for the worship of native Shinto spirits (*kami*). Although we cannot know what these very early gardens were like, we can surmise what must have been their underlying spirit: the presence of the *kami*. According to Shinto beliefs, spirits or gods manifest themselves in all aspects of nature, including mountains, trees, rocks, and waterfalls. As a result, nature directly reflects the beauty and purity of the gods. Shrines and areas deemed sacred by Shinto provide places for humans to encounter the gods in this world. Similarly, temple gardens provide a place for humans to come closer to Buddhist truth.

Besides providing spiritual settings, Japanese gardens are often specifically designed to evoke psychological and emotional responses in their viewers. The selection of rocks, trees, and shrubs is not merely a matter of constructing an aesthetically pleasing scene, but also reflects the desire to evoke certain emotions associated with certain seasons and their foliage. In this way, both the garden and the viewer share actively in the experience of nature.

The emotional and psychological associations of Japanese garden design are perhaps the most difficult aspects for Westerners to understand. These associations reflect not only the ear-

liest spiritual connections with Shinto, but throughout Japanese history they have been incorporated into literature, art, and daily life in a manner which has developed into a unique sensibility. Gardens reflect the attempt to commune and collaborate with the natural power and beauty of the divine. In deference to nature, the Japanese have always known that their own contribution to the collaboration can be only minimal, but participation and appreciation can reveal the empathy they feel for the forces of nature.

This empathy also enables the Japanese to appreciate the fleeting quality of beauty, knowing that as quickly as the cherry blossoms bloom, a gust of wind may blow them away. This appreciation is described as *mono no aware,* an acute and often melancholy sensitivity to things. The sensitivity to both the creation and the transience of beauty within nature makes spring and autumn the two seasons most precious to the Japanese sensibility. Spring is associated with freshness and new life, and autumn, despite its brilliant display of red, yellow, and orange foliage, evokes sadness.

In *The Tale of Genji* (see figure 24), the most significant literary work in Japanese history, Prince Genji builds a villa whose quarters correspond to the four directions associated with the four seasons. In each quarter of the villa he houses one of his favorite consorts. Genji not only associates each woman with a specific season, but has the garden of each woman's residence specifically designed to evoke the particular beauty and emotional qualities of that season:

> *In the spring, Lady Murasaki's southeastern garden, full of flowering trees, reached the ultimate in beauty. The scent of plum blossoms wafted into her chambers, creating an earthly paradise.*

Seasonal changes bring new foliage and new colors to gardens, highlighting different aspects and emotions at different times of the year. However, lack of color can be equally spectacular, as when a light blanket of snow covers a garden, creating a completely new aesthetic. As Genji himself notes:

> *A winter's night, when the moon shines glistening on the snow, is my favorite. Beauty without a hint of color brings forth a different world, more lovely and moving than ever.*

The different seasons and their resulting changes in foliage trigger certain activities as well as emotions. Hordes of Japanese can be found gazing at the fresh cherry blossoms in spring, for example, or welcoming the melancholy autumnal brilliance of red maple leaves in November. But this appreciation for natural beauty is not merely an excuse for leisure activities. The Japanese desire to be surrounded by natural beauty is part of daily life. Almost all homes have some form of "garden," although not always the type we traditionally expect. Even the most modest house or apartment can have a small area, perhaps only a few square feet, devoted to some sort of garden. Others will have meticulously tended "potted" gardens located on front porches or apartment balconies. The desire to bring a manageable portion of nature into the home led to the development of *bonsai,* meticulously clipped miniature trees, and *bonseki,* miniature rock and sand gardens arranged in small trays.

Buddhist Gardens

When Buddhism was introduced into Japan from Korea in the sixth century, the age-old connection between natural settings and the presence of spiritual values was further intensified. During

the sixth and seventh century, the idea that garden designs could serve as miniature representations of the Buddhist cosmos appeared. Therefore, by the eighth century, the term "garden" became strongly tied to spiritual beliefs, both native and borrowed.

BYODO-IN

One of the earliest Buddhist-influenced conceptions of gardens was based on the Pure Land of Amida, Buddha of the Western Paradise. The grounds of the Byodo-in (see figure 20), located west of Kyoto in Uji, serve as a metaphor for Amida's Pure Land. The site was originally the villa of Fujiwara Michinaga, a high-ranking courtier of the tenth century. Michinaga's son, Yorimichi, eventually inherited his father's villa and built the extensive palace now known as the Byodo-in. The palace was converted to a temple, and the only surviving building from the period, the Phoenix Hall, was dedicated in 1053.

The Phoenix Hall, which is said to be shaped like a phoenix with two outstretched wings, served as a chapel to Amida Buddha. The surrounding grounds are a physical representation of the glories and spiritual serenity associated with Amida's Western Paradise. Visitors first circle around a pond which forms the Sanskrit letter A, for Amida. Here, lotus leaves and flowers, symbolic in Buddhism for their ability to blossom even from the murkiest, muddiest waters, rise above the surface, providing another reminder of the Buddha's presence. Looking across the pond to the Phoenix Hall, viewers are confronted with the opulent yet delicate elegance of Heian-period architecture as the broad "wings" of the hall extend out and reflect in the water. The Byodo-in represents a unique opportunity to experience the glory and spiritual radiance of Amida's Western Paradise in this world.

On entering the Phoenix Hall, one is immediately struck by the radiant image of Amida Buddha and his retinue of celestial attendants (see figure 21). However, it is important to remember that the presence of Amida is not limited to the sculptural representation within the hall, but extends out to the veranda, the pond, and beyond. This is not primarily a meditative garden for solitary strolling or quiet sitting. Instead, the entire setting of the Byodo-in serves to provide a type of physical reassurance of Amida's presence and compassion. Pure Land Buddhism is the most accessible form of Buddhism because believers do not have to rely on their own abilities, but simply have faith in Amida. The radiant setting of the Byodo-in provides a place to celebrate this faith.

SAIHO-JI

Saiho-ji was originally the villa of Prince Shotoku Taishi (574–622), but it was transformed into a temple during the eighth century according to the wishes of Emperor Shomu (reigned 724–49). During the Kamakura period (1185–1392), the temple became associated with the Pure Land sect, and a small hall dedicated to Amida Buddha was constructed on the north side of the pond and named Saiho-ji.

In 1339, the temple underwent major reconstruction under the direction of the distinguished Zen priest Muso Soseki (1275–1351), who also brought Saiho-ji to Zen Buddhism. As his design reflects, Soseki was an avid gardener who believed in using nature for meditation. Pure Land gardens were designed as reminders to the faithful of the serenity and joy of Amida's Paradise, to surround them with spiritual bliss and security. In contrast, Zen gardens were meant for solitary meditation and contemplation.

Located in the western outskirts of Kyoto, Saiho-ji is also known popularly as Kokedera (the Moss Temple). Its grounds (figure 60) cover

approximately four and a half acres of dark, shaded forest, with a carpet of rich green moss that extends as far as the eye can see. The path through the garden curves around a pond that takes the shape of the Chinese character for "heart," appropriate because a pond is considered to be the heart of a garden.

Today, a visit to Saiho-ji is a unique experience. The temple is no longer open to the general public; in 1977, the abbot decided that irreparable damage was being done by the thousands of visitors who descended daily on the delicate moss grounds. As a result, visitors must now obtain permission (granted for a fee of about thirty-five dollars) and schedule their visit with the temple in advance.

On arriving at Saiho-ji, visitors cannot immediately start strolling through the garden. Instead, they are ushered in a group of thirty scheduled guests into the main hall, where they are seated on the floor in front of a small writing table outfitted with brush, ink, and a narrow slip of wood. The temple monks then file in and begin chanting the *Heart Sutra,* and give each visitor a copy of the Buddhist chant, written in Chinese characters. From the beginning, guests become active participants in their visit to Saiho-ji. Instead of just sitting passively listening to the chanting, all are encouraged to take part. Even Westerners who cannot read the sheet of Chinese characters are tempted to try to follow along.

Coming into direct contact with the practices of the temple, even if only for fifteen minutes, helps visitors to realize that the garden is not a public park, but part of a religious compound. Entering the main hall and participating in a brief ritual brings home the fact that Saiho-ji as a religious institution is still alive, functioning much as it did four centuries ago. It becomes clear that Zen is not a medieval spiritual and aesthetic remnant, but a vibrant, living tradition.

After the chanting, visitors are asked to take the brush and ink and write a short prayer or wish on the slip of wood. The slip of wood is placed in front of the main altar before the guests leave the hall and begin their trip through the garden.

As one of Japan's most celebrated strolling gardens, Saiho-ji provides a sense of peace and tranquility along with a striking visual experience. The path twists and turns around the pond so that strollers do not immediately gain a full view of the pond's entire expanse. The thick trees and lush green moss for which Saiho-ji is famous envelop the walker in quiet solitude. At first, all noises seem to be absorbed by the thick trees and moss; however, gradually one becomes aware of the sounds of the garden—the birds, the rustling trees, the rain beating on the pond, and the visitor's own footsteps against the stone path. More than one hundred varieties of moss grow at Saiho-ji, and just as the ear becomes accustomed to the new sounds, the eye gradually becomes accustomed to the subtle variations of colors and texture.

The difference in aesthetic style between large-scale Pure Land gardens and Zen gardens becomes most evident when we consider their different purposes. Zen art is not merely visual; it provides a feeling and an atmosphere conducive to quiet contemplation and meditation. In his *Dream Conversations,* Soseki commented that some people create gardens to impress others, some to collect rare trees and rocks, some to inspire their poetry, and some to clear their minds. He wrote, "People who understand that mountains, streams, earth, plants, trees, and rocks are all one with the fundamental self can make these natural features part of their meditation; this is what gardens signify to followers of the Way."

When Soseki transformed the original Pure Land garden into a Zen garden, he removed ex-

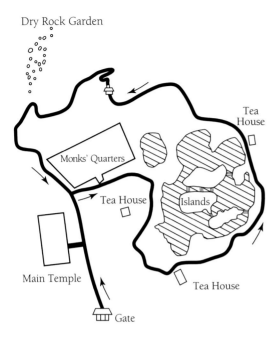

Dry Rock Garden

Tea House

Monks' Quarters

Tea House

Islands

Main Temple

Tea House

Gate

61. Plan of Saiho-ji (see figure 60)

nificent grove of bamboo. Soseki is believed to have meditated on one of these large, flat rocks. Despite the apparent contrasts between the rocks and the moss garden, they contribute to the same basic effect of solitude and aesthetic purity.

RYOAN-JI

When Zen Buddhism reached the height of its influence during the Muromachi period (1392–1568), both Zen monks and the military rulers of Japan developed a particular affinity for ink landscape paintings imported from China. The emergence in Japan of painter-priests such as Sesshu Toyo (1420–1506) greatly influenced Zen aesthetics, including the design of Zen gardens. Derived in part from the abstracted austerity of images such as Sesshu's *Broken-Ink Landscape* (see figure 28, page 60), the most important development of medieval Zen gardens emerged: the rock and gravel dry garden, or *karesansui*.

While Soseki designed the garden of Saiho-ji to be strolled through and meditated within, Zen dry gardens were designed as fixed spaces, composed of large rocks within planes of gravel, creating a purity that is based on austerity. The viewer is left to contemplate this space from a veranda running alongside the garden. This style of Zen rock garden is epitomized at the Zen temple Ryoan-ji in northwestern Kyoto.

In contrast to the moss-enveloped intimacy of Saiho-ji, the dry garden of Ryoan-ji follows a more traditional approach to Zen aesthetics. The grounds of the temple were originally the estate of the high-ranking Fujiwara family during the Heian period (794–1185). The estate then fell into the hands of the Hosokawa family and was transformed into a Zen temple in the fifteenth century. The structures of the temple were destroyed during the Onin War (1467–69) but were eventually rebuilt in the late fifteenth century.

isting pavilions, altered buildings, and added three large and four small islands to the pond (figure 61), ensuring constant changes in scenery on a walk through the garden. On rainy days, the small moss-covered bridges that crisscross the pond, connecting the islands at various points, create an elegant pattern of arches rising from the mist. Several tea houses subtly punctuate the landscape with their natural, rustic exterior surfaces and architectural simplicity.

Soseki's main achievement in redesigning Saiho-ji as a Zen garden was to divide the space into two distinct parts: the classic pond-centered garden below, and a smaller rock garden above. Thus, after strolling through the garden and around the pond to quiet the mind, one enters the upper portion of the garden, which consists of groupings of large rocks set next to a mag-

The famous rock garden at Ryoan-ji (figure 62) is believed to have been constructed around 1500. As well as suiting the tastes of the time, there was also a practical purpose for the creation of this type of Zen rock garden. The civil unrest of the Onin War had left much of Kyoto in ruins with many Zen temples destroyed, and the reconstruction of these temples was costly. However, dry rock gardens were much less expensive to build than the previously popular pond-centered gardens.

In the dry garden, an expanse of water can be represented within a limited space by white sand or pebbles. The monumental mountains of Sesshu's ink paintings are now suggested by rocks, manageable in size, but, within the restrained scheme of the garden, no less imposing than their natural counterparts. Constructed with fifteen large rocks, the Ryoan-ji garden represents the *karesansui* aesthetic in its purest form—with no water, trees, or shrubs.

The garden is most noted for its restraint and stark mystery. The rocks themselves are not particularly large, tall, or monumental. In fact, some are sunk so deeply into the gravel that most people do not notice them until carefully studying the composition. The garden rewards prolonged contemplation; after a while, even the patterns in the raked gravel seem more vivid. This use of space compares to Zen paintings in which form and emptiness are equally important,

62. Ryoan-ji. 16th century. Kyoto

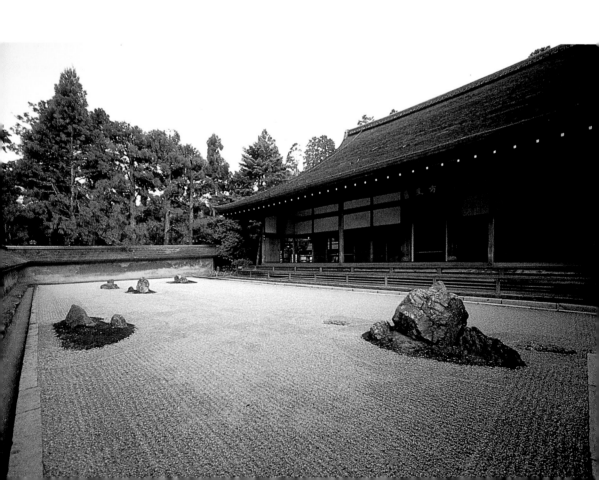

not only to the composition but to its spiritual resonance.

Ryoan-ji's large rocks are widely distributed amid the large area of gravel, at first seeming to have little or no relationship to one another. However, after sitting in front of the garden for some time, the viewer becomes aware of how the rocks balance each other within the overall composition, not simply occupying space, but defining it. What is most interesting, and perhaps most Japanese, is the asymmetrical juxtaposition of natural rock forms within the rigid angular confines delineating the space.

The arrangement of the rocks has been analyzed many times. Beyond the general grouping of the rocks into seven, five, and three, there has been little agreement about how they are organized. Among other things, the rocks have been described as "islands in the sea" and a "tigress and cubs swimming across a river." As with Sengai's painting *Circle, Triangle, and Square* (see figure 31), perhaps too much emphasis has been placed on trying to verbalize the Zen meaning behind the design. The most important meanings lie in what we find in the experience—in how the two aspects of shapes, natural and geometric, work together, and what this combination of forms communicates about Zen aesthetics.

Despite the fact that Ryoan-ji is a dry garden, the way one sees it is subject to the changing season, weather, and time of day. For instance, the bright sun of a warm summer day will enhance the surface textures of the rocks and bring out the colors of the moss and the surrounding walls. On cloudy days, the garden reveals much more somber tones, as the shades of gray meld together, emphasizing the garden's austerity. In particular, the surrounding walls, built from clay soaked in boiled oil, have developed a rustic patina of umber and gray, the result of oil seeping out over time. Even more intriguing, during a cloudburst the force of the raindrops causes the pebbles to dance lightly on the garden's surface.

Since Ryoan-ji has become a major cultural attraction, the tranquil setting of this Zen garden is often bustling with tourists and groups of Japanese schoolchildren on field trips. During the busiest times, a loudspeaker above the heads of visitors blasts information about the garden. But in the early morning and on rainy days, fewer visitors come, and the loudspeaker is silent. Sitting on the veranda during these quiet moments, and slowly becoming aware of all of the subtle aspects of the setting, a visitor can more fully understand how complex this "simple" garden is—the depth within the simplicity of Zen.

TOFUKU-JI
While the garden at Ryoan-ji may exemplify the Zen dry-garden aesthetic, it by no means defines it. Over the centuries, dry rock-garden designs have taken many forms, and innovative interpretations have continued in the twentieth century. One of the most dynamic approaches to traditional Zen rock-garden design is found at Tofuku-ji in southeastern Kyoto.

The expansive grounds of Tofuku-ji contain centuries-old wooden bridges crossing famous gorges filled with maple trees. These provide sufficient evidence of nature's ability to inspire, yet several gardens within the temple compound show humanity's continuing effort to respond. The Ryo-gin-tei (Dragon Song Garden), created in 1964 by Mirei Shigemori (1896–1975), reveals the aesthetic power of Zen dry gardens in a much different manner than at Ryoan-ji.

In place of a tranquil sea of horizontally raked gravel, this garden incorporates low concrete barriers that both break up and contain free-flowing pools of gravel within a rectangular space of 231 square meters (figure 63). The em-

phasis on borders is not restricted to the outskirts of the garden proper, but actually enters and enlivens the garden design. From amid the turbulent swirls of light and dark gray gravel, tall peaks of rock jut out in different directions, with much more energy and dynamism that those at Ryoan-ji. In many ways, this modern garden, through its use of animated space and monumental rock formations, carries the spirit of ink landscape paintings of the Muromachi period into the modern age; rock groupings in the Ryo-gin-tei appear to be mini-landscapes.

Adding to the sense of energy is the dynamic pattern of dancing concentric squares on the wooden fence flanking the right side of the garden. This curious design also serves to draw the eye upward and out, away from the garden. Compared to Ryoan-ji, which encourages inward meditation through aesthetic tranquility and austerity, Ryo-gin-tei seems to encourage us to wake up, look around, and become aware of the energized surroundings. Perhaps the contrasts in these two dry gardens reflect two aspects of the Zen mind: the serene and the dynamic.

The modern gardens surrounding the abbot's quarters at Tofuku-ji, also designed by Mirei Shigemori in 1938, were constructed in conjunction with a project to replace many of the temple structures destroyed by fire in 1881. In contrast to the garden of Saiho-ji (meant to be enjoyed by strolling through) and the rock garden at Ryoan-ji (designed to be contemplated at a distance, from the veranda), the gardens running along the western and northern sides of the Abbot's Quarters are meant to be viewed from a narrow wooden walkway.

The small garden on the west side of the Abbot's Quarters contains only a simple arrangement of low-lying azalea hedges, carefully clipped into a checkerboard pattern (figure 64). The hedges fill only one corner of an otherwise unobtrusive moss- and gravel-filled space, but in the spring they explode with brilliant pink blossoms. Continuing around the corner of the hall to the north side, the checkerboard motif is maintained through the use of stone-imbedded moss. Gradually, however, the checkerboard pattern begins to break up, becoming more random and less controlled (figure 65). This opening up of the pattern serves also to open up the space, leading the eye along the squares and eventually up and out to the surrounding maple trees and foliage. The design reveals not only a brilliant use of space, but also a wonderfully animated sense of asymmetry. Are these gardens truly Zen-inspired, or are they merely modern designs set within a Zen temple compound? Zen, of course, can be represented in many surprising ways. Perhaps the simple unexpectedness of finding such a contemporary design can be considered Zen in spirit.

At first, the visual directness of the checkerboard motif may seem too modern and geometric, but the layout of the two gardens is left simple and the space is unencumbered, thereby enhancing rather than overwhelming the natural panorama of the surrounding temple grounds. Natural forms had been juxtaposed with angular shapes in the Ryoan-ji dry garden. At Tofuku-ji, the geometric emphasis reveals a different aesthetic, and evokes a different response. The gardens around the Abbot's Quarters, meant to be seen while walking, show the transformation of the checkerboard pattern, and thus become art seen through time, while Ryoan-ji remains timeless, evoking the universality of meditation.

Opposite:
63. Ryo-gin-tei, Tofuku-ji. 1964.
Kyoto

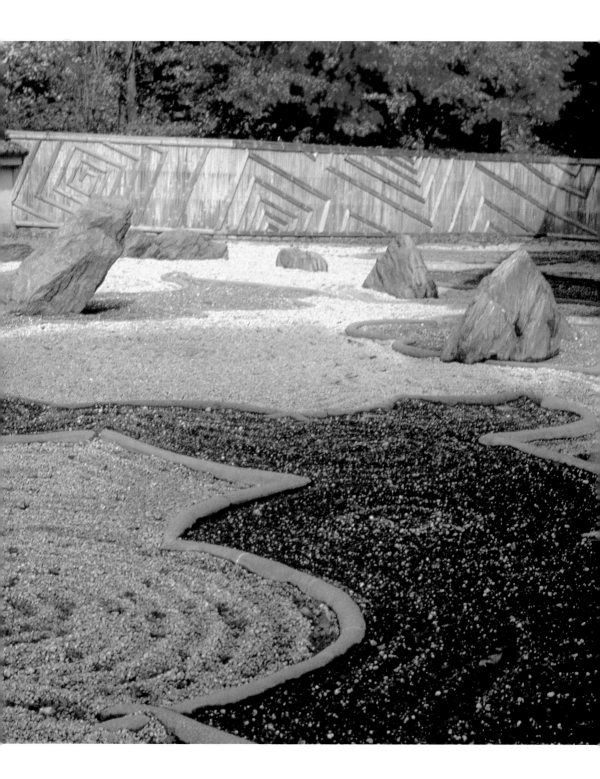

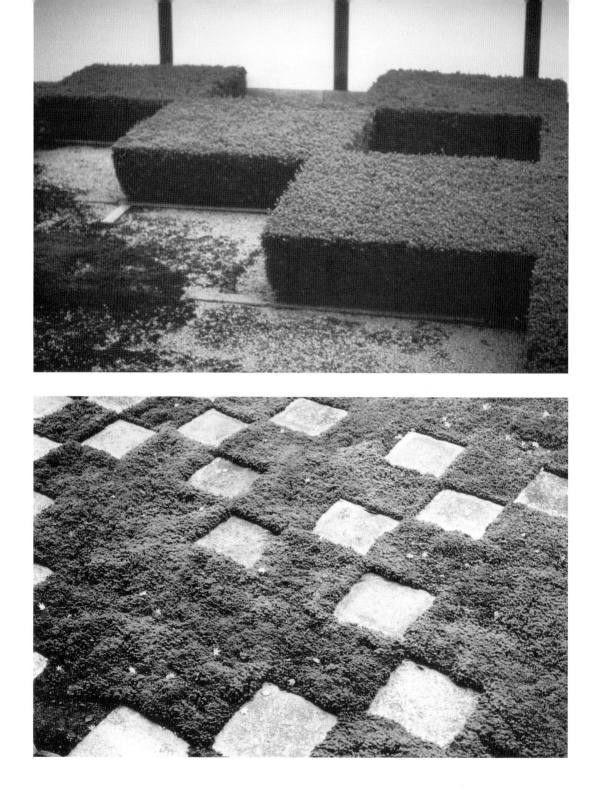

Secular Gardens

Besides the influence of religion, the role of secular patrons was also vital to the development of gardens in Japan. Personal gardens were generally places for leisure activity; they were either settings where nobles or scholars could enjoy the company of friends, in an atmosphere revealing their highly developed aesthetic sensibilities, or simply areas where individuals could quiet the mind and find poetic inspiration in communion with nature. The history of aristocratic gardens, which first flourished in the tenth through twelfth centuries, is long and complicated. In general, however, the architectural and garden settings of the court were places where the elite could enjoy the changing seasons, while at the same time demonstrating their highly developed aesthetic knowledge and abilities.

SHUGAKU-IN
Situated on 133 acres in northeastern Kyoto, the grand villa of Shugaku-in was the private retreat of the retired Emperor Gomizuno-o (reigned 1611–29), a man of great aesthetic taste and artistic skill who is believed to have been active in the selection and design of the site.

Like Saiho-ji, Shugaku-in requires visitors to obtain permission in advance, in this case from the Imperial Household Agency. As a result, guests feel that they are entering the private re-

Opposite, above:
64. Azalea hedges in garden outside Abbot's Quarters, Tofuku-ji. 1938. Kyoto

Opposite, below:
65. Checkerboard garden, north side of Abbot's Quarters, Tofuku-ji. 1938. Kyoto

serve of the Japanese nobility. Rather than simply a garden, Shugaku-in is its own self-contained world. The compound is comprised of three separate villas, each with a private garden, at various elevations on terraced fields at the foot of Mount Hiei. Shugaku-in represents one of the finest examples of strolling gardens, due in part to its size, but also in the way its three villas are distributed amid the lush, intricate landscaping of the hillside. As a consequence, the grounds are deceptive, since the entire expanse is not visible from any single point (figure 66).

Today, guests are taken through the grounds in small groups. Strolling between the villas scattered along the hillside, they can begin to see the broader landscape, including the grandeur of Mount Hiei directly behind the villa (figure 67). The general terrain of the site also includes pine-tree-lined roads through fields which continue to be farmed by local people. Closer to each villa, however, the scenery changes; everything becomes more focused and more intimate. The large world disappears, replaced by the private world of Emperor Gomizuno-o and his consort.

The three villas are dispersed to different sides of the compound. While the checkerboard hedges at Tofuku-ji provided a way of unifying space, at Shugaku-in hedges are used to conceal the dam that creates the three-acre Pond of the Bathing Dragon. The individual villas, nestled quietly into the hillside, each have their own private gardens. The main structure of the Lower Villa is the Jugetsu-kan (Moon of Longevity Hall). To reach this villa, it is necessary to pass through several gates, then enter a small garden containing a stream which flows from Mount Hiei. Following the small path and crossing several narrow bridges leads through an area dotted with stone lanterns of intriguing shapes, including the Sleeve-shaped Lantern. Despite the lush foliage leading up to the villa, the area immedi-

ately surrounding the front of the structure is kept rather bare and simple. The entrance to the villa consists of a path of large flat stones, and the garden is held at a distance so as not to overwhelm the simple lines of the architecture.

On leaving the Lower Villa, a pine-tree-lined gravel path leads past agricultural fields to the Middle Villa, which was not part of the original plan of Shugaku-in but incorporated in the Meiji period (1868–1911). The path to the Upper Villa cuts sharply uphill, eventually reaching a long, narrow flight of stone steps flanked on both sides by tall hedges that block the view. Finally, visitors emerge from the shaded path into the sunlight and turn to see the astonishing panorama of the valley below. The Upper Villa contains the Rin'un-tei (Forest Cloud Pavilion), a light and airy structure with no walls that is enclosed only by sliding paper screens. Although this pavilion is surrounded by its own simply landscaped garden, it is the broad view of the valley that constitutes its true "garden."

From the Upper Villa, a landscape filled with maple and pine trees can be seen, including the rather extensive man-made pond. This perspective not only provides an idea of the expansiveness of Shugaku-in, but more important, shows how the entire site is carefully situated within the natural setting of Mount Hiei and the surrounding landscape. This effect is called *shakkei* ("borrowed scenery"), in which gardens are incorporated into a natural setting, allowing the two to merge.

Gomizuno-o's son, the Emperor Reigen (reigned 1663–87), visited his father's retreat often and was very fond of the site. On his last visit, he wrote of seeing the autumn leaves:

After a light meal we took the path along the stream called the Otowa-gawa and arrived at the Rin-un-tei. The leaves had already fallen

66. Plan of Shugaku-in (see figure 67)

Opposite:
67. Shugaku-in. 17th century. Kyoto

from the maple that stands at the edge of the eaves, but one other large tree was still brilliantly dressed in scarlet. Other trees were scattering their leaves on the ground, while still others had not yet turned red. Here I composed a poem:

> *Few leaves remain*
> *On trees already past the prime*
> *Of autumn splendor.*
> *Now the mountain wind comes hurrying*
> *To dye the green trees red.*

(From The Architecture of the Japanese Garden, translated by Richard Gage and Akira Furuta)

Even today, we can share the breadth and elegance of this retired emperor's country retreat, just outside the bustling modern city of Kyoto. The ability to experience an otherwise unfamiliar time and aesthetic in such a personal way is one of the reasons why gardens remain such an important feature of Japanese art and culture.

SHISENDO

Not all private gardens were expansive villas for the aesthetic pursuits of retired emperors and their consorts. Another important form of Japanese garden is that for the scholar.

We have already seen how the artistic-scholarly ideal was widely appreciated and pursued by the literati of Japan in their painting and calligraphy (see figures 34–36, 42, 44). Just as their brushwork reflected the artists' personal connections with the glories of nature, so too did their gardens reflect their personal inclinations. Here, the symbols which come to life through the strokes of their brush as poetic or painted imagery surround them in natural forms. For the literati artists, nature, poetry, painting, and scholarship were viewed almost as a single entity—as interrelated elements of their aesthetic ideal. In this way, the scholar garden was not merely a pleasing arrangement of natural elements, but a setting conducive to the pursuits of mind and body.

One of the finest examples of a scholar garden is the Shisendo in northeastern Kyoto. Once the private retreat of the poet and calligrapher Ishikawa Jozan (1583–1672; see figure 42), the intimate grounds of the Shisendo are now open to the public. In contrast to the grandeur of Shugaku-in, the Shisendo represents a quiet, solitary retreat outside the city where the poet Jozan and a few guests could retire to compose poetry, drink tea, and enjoy each other's company.

From the quiet street that runs in front of the Shisendo, a small and rather ordinary gate opens to Jozan's private world. From this unpretentious portal, a narrow path of stone steps leads to another small gate, beyond which is the main structure. Immediately striking are the rusticity of the building and the way it blends quietly into the natural setting. The architecture is also notable for subtle Chinese-style details, such as the round and fan-shaped windows and the wooden calligraphic signboards hung above the gateways.

Within the building is the room known as the Hall of the Immortal Poets, with small portraits of Jozan's selection of the Thirty-six Immortal Chinese Poets running along the tops of the walls. Just beyond this hall is a large, airy room which opens out to the garden on two sides (figure 68). The simple lines and open space of the architecture harmonize with the garden to enhance the scholar's union with nature. This careful balance not only allows the room to extend out into the garden, but also invites the beauty of nature to commune with the spirits of the Immortal Poets. From the veranda of this room, the visitor is invited to gaze out on the serenity of Jozan's personal garden, with its large pool of white sand enveloped by carefully clipped azalea shrubs and tall trees.

After entering the garden from the adjacent room, called the Den of Supreme Happiness, there is a path across a small rivulet called the Shallow of the Floating Leaves; a walk through shaped shrubs and down stone steps leads to the lower garden. While less intimate than the garden adjacent to the house, the lower garden provides a private area in which people can stroll about in contemplation, surrounded by constantly changing aspects of nature. Central to the lower garden is a small pool with carp, next to which pampas grasses sway and shimmer in the

68. Shisendo. 17th century. Kyoto

afternoon sun. At the bottom of the garden stands a large grove of tall bamboo, a favorite symbol to the literati because of its ability to bend in the wind without breaking. The lower garden circles back at the bamboo grove, affording yet another view of the Shisendo. Returning toward the structure, one sees the Tower for Whistling at the Moon, situated above the Hall of the Immortal Poets, rising up amid the trees. Along the path, one will also encounter a *sozu* (water mortar or deer scarer), a bamboo tube balanced on a pivot. Water from a tiny stream enters the tube, which, when full, tips from its own weight; the water spills out and the tube pivots back, striking a stone beneath it. The sound of the bamboo striking the stone was first used to scare away wildlife which might damage the garden, but the reverberation of its sound also serves to intensify the otherwise peaceful and solitary atmosphere of the garden.

One can imagine Jozan, like Taiga's solitary flute player floating in the moonlight (see figure 34), enjoying scholarly pursuits in his private world. His poems give us a picture of him quietly writing and creating his unique calligraphic images, surrounded and inspired by his garden.

IN THE GARDEN—IMPROVISED
The year's second month, living in the
mountains—
embroidered cherry blossoms beautiful to view!
I am so moved, dinner is forgotten—
old, I mourn spring's passing more than ever.
Swift sounds of wind through a thousand
blossoms;
setting sunlight halfway down the bamboo.

Opposite:
69. The International House.
1952. Tokyo

This poem is done—I'm too lazy to revise it;
I'll leave every word as it came from my brush.
(From Shisendo: Hall of the Poetry Immortals, *translated by Jonathan Chaves*)

THE INTERNATIONAL HOUSE

We have examined several gardens of great historical as well as aesthetic importance. However, it is important to remember that gardens continue to be significant and influential aspects of Japanese culture today. But how does a modern industrial society adapt the ancient tradition of garden design to its contemporary needs? Historically, the Japanese have been adept at taking diverse cultural elements—religious, aesthetic, and intellectual—and transforming them to express their own spirit. Gardens are no exception. In a country in which thatched-roof farmhouses, wooden temples, and concrete high-rises coexist, reflecting changing aesthetic and functional needs, gardens continue to be adapted to suit changes in people's experience of the world.

Originally the private residence of the founder of the Mitsubishi Corporation, the International House in Tokyo was established in 1952 as a private, nonprofit organization dedicated to cultural exchange. While the architecture is clearly modern and Western, based on strong angles formed by large planes of concrete and glass, the adjoining gardens were created with traditional Japanese tastes in mind. Designed by Kunio Maekawa, Junzo Yoshimura, and Junzo Sakakura, the landscape has been carefully arranged around the architecture.

The main garden behind the structure reaches high up along an embankment. By means of narrow paths that twist and wind up the slope, a great sense of space and depth has been created. These paths, which include variously shaped stepping stones, are shielded by trees and tall shrubs that break up the line of

sight, thereby manipulating the space and causing it to seem larger than it is.

The lower garden is designed to enhance the ground-level architecture, especially where the corner of the formal dining room juts out over the fish pond (figure 69), a design commonly seen with Japanese verandas. This is similar to the way the architecture of the Shisendo juts out into the garden. The most impressive feature of the International House garden design, however, is the manner in which the rest of the multi-level structures are incorporated. The roofs of three buildings are actually landscaped with lawn (a modern, Western influence) as well as shrubs and trees, so that several levels of gardens extend different distances into the landscape. More important, because the formal garden across from the buildings is situated on a hillside and thus appears terraced, levels of gardens also appear to extend from both sides of the site. This type of design compares to the rooftop gardens found on high-rise apartment complexes in American cities, but here it is fully integrated with the larger garden at ground level.

Strolling through the formal garden on the hillside, it is not evident that the visitor is in the center of Tokyo, since thick trees and shrubs screen the view of surrounding buildings. However, the architecture of the International House itself, with many large glass windows, is designed to feature multiple views of the gardens. Just as the ground-level formal dining room juts out over the fish pond, the less formal coffee shop on the second floor is situated so that the viewer sees a rooftop garden in the foreground, with the more complex hillside garden as the backdrop. This view of multiple garden levels is also available from many of the guest rooms. From a distance, the full but shallow space of the hillside garden appears like a rich tapestry of textures, with the continuity of round shrubs and trees juxtaposed against the angular architecture and square areas of lawn. The resulting variety—of spaces, textures, and shades of green—contrasts with the architecture of the building and provides a living, growing presence in the middle of a modern metropolis.

By considering the size, design, and purpose of both religious and secular gardens, we can gain a better understanding of the Japanese appreciation of nature. Gardens are the home of *kami,* places for private pleasure, and representations of culturally refined poetic vision. In all their manifestations, they reveal the aesthetic and spiritual soul of Japan. By learning to look at various types of gardens, we can understand the Japanese desire to create not merely beautiful landscapes, but also psychologically and emotionally rich, living compositions that change with the seasons and the ages.

Key Questions When Looking at Gardens

Scale. When entering a garden, what is the scale of the garden to the viewer, and of different aspects of the garden to each other? Do some of the smaller areas act as mini-landscapes, standing independently but contributing to the larger composition?

Shapes and Contours. How are different parts of the garden shaped? How do they work side by side? Do some shapes enhance each other by echoing repeated themes? Or do they offset each other by contrasting shapes? How are the geometric shapes juxtaposed against organically shaped elements?

Seasonal Changes. In what season of the year are you visiting? What effect does this have on the foliage and overall atmosphere of the garden? For instance, do you feel a sense of rejuvenation if it is spring, or a more somber atmosphere if it is autumn or winter? If so, how was this achieved? Can you imagine the garden in other seasons?

Materials and Textures. What materials have been used for fences, bridges, or buildings? How are various materials combined, and what is the overall aesthetic effect created by placing different elements together? How does the weather affect the materials? Does the aesthetic quality change when the elements are wet with rain?

Looking in All Directions. Where are you walking? Does the path you are following change as you progress? Why? If you cross a pond, by what means do you cross it? Look again at the materials being used. Are there bridges which you do not cross, or paths you do not take? What purpose do they serve? Do they carry your eye, if not your body, through space?

Water. Is water used, in ponds, streams, waterfalls, or water basins? Is it merely suggested, as in dry gravel gardens? How do viewers interact with the water? Do they simply admire it from a distance? Do they cross over it by means of a bridge? Do they use it in a basin?

Daily Activity. What kind of human activity is occurring? Can you see people working in the gardens during your visit? How do gardens show our attempt to respond to nature—to be able to commune with it, if not control it? What do they reveal about the fundamental Japanese love for, and identification with, nature?

SUGGESTIONS FOR FURTHER READING

Among the many books on Japanese art, those included here may be especially helpful. The books marked with an asterisk are out of print, but may be available in good libraries.

GENERAL

Kodansha Encyclopedia of Japan. 9 vols. Tokyo and New York: Kodansha International, 1983. A most useful compendium of essays, including many on art and artists, by leading Japanese and Western scholars.

Mason, Penelope. *Japanese Art.* New York: Harry N. Abrams, 1993. A thorough historical study of Japanese art, focusing on architecture, sculpture, and painting, with copious illustrations and an extensive annotated bibliography by Sylvan Barnet and William Burto.

Noma, Seiroku. *The Arts of Japan.* 2 vols. Tokyo and Palo Alto, Calif.: Kodansha International, 1966–67. Beautifully illustrated volumes, with short essays and extended plate captions translated and adapted from the Japanese originals.

Paine, Robert Treat, and Alexander Soper. *The Art and Architecture of Japan.* 3rd ed., Baltimore: Penguin Books, 1981. First published almost forty years ago, this volume remains useful for its strong, scholarly text; illustrations are in black-and-white.

Stanley-Baker, Joan. *Japanese Art.* New York: Thames & Hudson, 1984. A small-size survey of Japanese art, written by a specialist in Chinese art, with twenty color plates and many black-and-white illustrations.

Tsunoda, Ryusaku, et al. *Sources of Japanese Tradition.* New York: Columbia University Press, 1958. Translations of sections of primary documents in Japanese history, religion, and literature.

Varley, H. Paul. *A Cultural History of Japan.* Honolulu: University of Hawaii Press, 1973. While not focusing on art, this book sets the stage by examining the historical and cultural foundations of the different eras of Japanese history.

MUSEUM COLLECTION CATALOGUES

The Freer Gallery of Art, vol. 2: *Japan.* Tokyo: Kodansha Ltd., 1972. A large-format catalogue of Japanese works in the Freer Gallery in Washington, D.C.

Kakudo, Yoshido. *The Art of Japan.* San Francisco: Chronicle Books and Asian Art Museum of San Francisco, 1991. Catalogue of the Asian Art Museum of San Francisco.

Smith, Lawrence, et al. *Japanese Art: Masterpieces in the British Museum.* London: British Museum Publications, 1990. The collection of the British Museum in London, with some works on loan.

A Thousand Cranes: Treasures of Japanese Art. San Francisco: Chronicle Books, 1987. The catalogue of the collection of the Seattle Art Museum.

CERAMICS: GENERAL

Ceramic Art of Japan. Seattle: Seattle Art Museum, 1972. A catalogue of a major exhibition of works from Japan.

*Mikami, Tsugio. *The Art of Japanese Ceramics*. New York: Weatherhill; Heibonsha, 1972. A survey of works from the Jomon through the Edo periods.

*Sanders, Herbert H. *The World of Japanese Ceramics*. Tokyo and New York: Kodansha International, 1968. Out of print, but still useful in introducing the methods of ceramic making in Japan.

Simpson, Penny, et al. *The Japanese Pottery Handbook*. Tokyo, New York, and San Francisco: Kodansha International, 1979. Although it does not discuss historical pottery, this handbook is very useful in explaining Japanese pottery terms and techniques, with many sketch illustrations.

CERAMICS: PERIODS AND STYLES

Baekeland, Frederick, and Robert Moes. *Modern Japanese Ceramics in American Collections*. New York: Japan Society, 1993. The most thorough and useful guide in English to modern Japanese ceramics.

Cardozo, Sidney B., and Masaaki Hirano. *The Art of Rosanjin*. Tokyo: Kodansha International, 1987. A delightful book about Japan's most famous early-twentieth-century master of ceramics.

*Cort, Louise Allison. *Shigaraki, Potters' Valley*. Tokyo: Kodansha International, 1979. A thorough and fascinating study of one of Japan's most celebrated ceramic areas and the works that were produced there over the course of six centuries.

Egami, Namio. *The Beginnings of Japanese Art*. New York: Weatherhill; Heibonsha, 1973. A survey of works from the Jomon through the Tomb periods.

Fujioka, Ryoichi. *Shino and Oribe Ceramics*. Tokyo: Kodansha International, 1977. Includes a useful introductory essay, "Ceramics and the Tea Ceremony," by Samuel Crowell Morse.

*Nakagawa, Sensaku. *Kutani Ware*. Tokyo: Kodansha International, 1979. A well-illustrated volume on one of the most popular of Japanese ceramic traditions.

The Rise of a Great Tradition: Japanese Archaeological Ceramics from the Jomon through Heian Periods. New York: Japan Society, 1990. The catalogue of an exhibition of early ceramics, including *haniwa*.

Wilson, Richard. *Ogata Kenzan*. New York: Weatherhill, 1991. A thoughtful and well-illustrated account of Kenzan, Japan's most famous name in pottery.

SCULPTURE AND TRADITIONAL BUDDHIST ART

Hempel, Rose. *The Golden Age of Japan, 794–1192*. New York: Rizzoli International, 1983. A large-scale volume covering both the religious and secular arts of the Heian period.

Kidder, J. Edward. *Masterpieces of Japanese Sculpture*. Tokyo: Bijutsu Shuppan-sha, 1961. Difficult to find, but an excellent survey.

*Kyotaro, Nishakawa, and Emily J. Sano. *The Golden Age of Japanese Sculpture*. Fort Worth: Kimball Art Museum, 1982. The catalogue of an exhibition of sculpture that came to America from Japan.

Mino, Yutaka, et al. *The Great Eastern Temple*. Chicago: The Art Institute of Chicago; Bloomington: Indiana University Press, 1986. The catalogue of an exhibition that came to the United States from Nara, featuring examples of sculpture and other arts from Todai-ji, Japan's largest temple.

Mizuno, Seiichi. *Asuka Buddhist Art: Horyu-ji*. New York and Tokyo: Weatherhill; Heibonsha, 1974. Describes and illustrates Japan's oldest and most famous temple and its many works of art.

Mori, Hisashi. *Japanese Portrait Sculpture*. Tokyo and New York: Kodansha International; Shibundo,

1977. Includes the famous portrait of Ganjin and many other interesting works.

————. *Sculpture of the Kamakura Period*. New York and Tokyo: Weatherhill; Heibonsha, 1974. Illustrates many famous examples of sculpture from Japanese temples and museums.

Rosenfield, John M., and Elizabeth ten Grotenhuis. *Journey of the Three Jewels*. New York: The Asia Society, 1979. The catalogue of a fine exhibition of Japanese Buddhist paintings from Western collections.

Sawa, Takaaki. *Art in Esoteric Japanese Buddhism*. New York and Tokyo: Weatherhill; Heibonsha, 1972. Discusses and illustrates the painting, sculpture, and temples of esoteric Buddhist sects.

SECULAR AND ZEN PAINTING
Addiss, Stephen. *The Art of Zen*. New York: Harry N. Abrams, 1989. Discusses the lives and art of Zen Masters from 1600 to 1925, including Fugai, Hakuin, and Sengai, with many color and black-and-white illustrations.

Akiyama, Terukazu. *Japanese Painting*. Cleveland: World; Skira, 1961. Although this book focuses primarily on the paintings of earlier periods, it is well written and well illustrated.

Barnet, Sylvan, and William Burto. *Zen Ink Paintings*. New York: Kodansha International, 1982. In large format, this book offers excellent illustrations of major Zen works of all periods with a clearly written text.

*Cahill, James. *Literati Painting: The Nanga School*. New York: The Asia Society, 1972. Now out of print, this exhibition catalogue is the best general introduction in English to Japanese literati painting.

Mizuo, Hiroshi. *Edo Painting: Sotatsu and Korin*. New York and Tokyo: Weatherhill; Heibonsha,

1972. Discusses and illustrates the works of the two greatest Rinpa School masters.

Murase, Miyeko. *Masterpieces of Japanese Screen Paintings: The American Collections*. New York: Braziller, 1990. Large in size, this offers reproductions of major screens in American museums and collections.

Okudaira, Hideo. *Narrative Picture Scrolls*. New York and Tokyo: Weatherhill; Shibundo, 1973. Includes such works as *The Frolicking Animals* and *The Tale of Genji*.

CALLIGRAPHY
Nakata, Yujiro. *The Art of Japanese Calligraphy*. New York: Weatherhill; Heibonsha, 1973. A loosely organized survey based on types of scripts, with many illustrations.

*Rosenfield, John M., Fumiko E. Cranston, and Edwin A. Cranston. *The Courtly Tradition in Japanese Art and Literature*. Cambridge, Mass.: Fogg Art Museum, Harvard University, 1973. A catalogue of works in the Hofer and Hyde Collections, which included many examples of *sutra* and poem calligraphy.

Shimizu, Yoshiaki, and John M. Rosenfield. *Masters of Japanese Calligraphy*. New York: Asia Society and Japan House, 1985. The catalogue of the first major exhibition of Japanese calligraphy in American collections.

Words in Motion: Modern Japanese Calligraphy. Washington, D.C.: Library of Congress, 1984. The catalogue for an exhibition of contemporary Japanese calligraphy, with essays by Aoyama San'u, Stephen Addiss, Barbara Rose, and Yanagida Taiun.

PRINTS
Hillier, Jack. *Japanese Colour Prints*. Rev. ed., London: Phaidon Press, 1991. An inexpensive survey of prints by a noted English authority.

*Lane, Richard. *Images of the Floating World*. New York: Dorset Press, 1978. A survey of prints that also contains a useful dictionary of artists and terms.

*Michener, James A. *Japanese Prints*. Rutland, Vt.: Charles E. Tuttle, 1959. An extensive and nicely illustrated text by the famous novelist and collector.

Newland, Amy, and Chris Uhlenbeck, eds. *Ukiyo-e to Shin Hanga*. London: Magna; Bison Books, 1990. A series of essays with color photographs on different periods of Japanese prints, with twentieth-century prints well represented.

*Stern, Harold P. *Master Prints of Japan*. New York: Harry N. Abrams, 1969. Generously illustrated with prints by the major masters of *ukiyo-e*.

Tolman, Mary and Norman. *Toko Shinoda: A New Appreciation*. Rutland, Vt.: Charles E. Tuttle, 1993. The first book in English on a major contemporary Japanese calligrapher, abstract painter, and printmaker.

GARDENS

Hayakawa, Masao. *The Garden Art of Japan*. New York: Weatherhill; Heibonsha, 1973. An all-around survey with many photographs.

Itoh, Teiji, and Takeji Iwamiya. *Imperial Gardens of Japan*. New York and Tokyo: Weatherhill, 1968. Large and beautifully photographed, this book includes essays on the Shugaku-in, Katsura, and Sento gardens.

Rimer, J. Thomas, et al. *Shisendo: Hall of the Poetry Immortals*. New York: Weatherhill, 1991. A well-illustrated study of the Shisendo garden and the life, poetry, and calligraphy of its creator, Ishikawa Jozan.

Slawson, David. *Secret Teachings in the Art of Japanese Gardens*. New York and Tokyo: Kodansha International, 1987. A study in depth of the technical aspects of Japanese garden design.

Treib, Marc, and Ron Herman. *A Guide to the Gardens of Kyoto*. Tokyo: Shufunotomo, 1980. Although difficult to find, this book is useful for studying the major Kyoto gardens.

INDEX

Photograph Credits

Stephen Addiss: figures 1, 2, 8–10, 19–23, 29, 30, 34–36, 42, 44, 46, 54, 58, 59. Benrido, Inc., Tokyo: figure 18. Fogg Art Museum, Harvard University, Cambridge, Massachusetts: figure 37. The Metropolitan Museum of Art, New York. All rights reserved: figure 49; © 1979, figure 50; © 1989, figure 55 and title page; © 1994, figure 52. © 1993 Museum Associates, Los Angeles County Museum of Art. All rights reserved: figure 7. © 1994 The Nelson Gallery Foundation. All reproduction rights reserved: figure 57. Sakamoto Manschichi Research Library, Tokyo: figures 11, 15, 25, 32, 34. Audrey Yoshiko Seo: figures 60, 63–65, 67–69. © 1994 Michael S. Yamashita: figure 62.